564

IMAGES
of America

SCOLLAY SQUARE

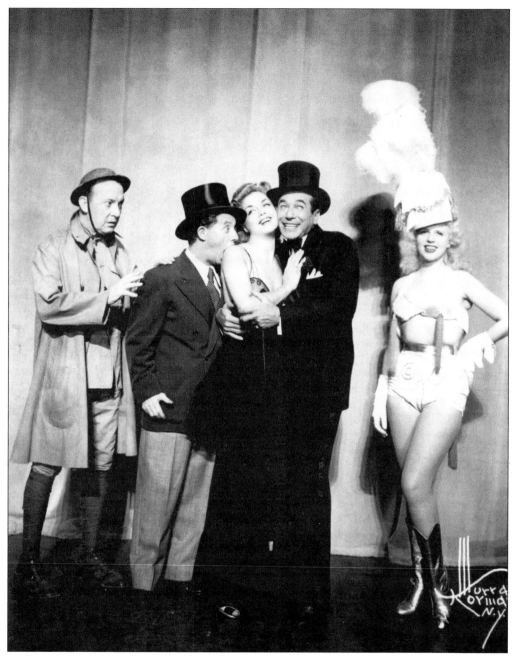

Performers "ham it up" for a publicity photograph in the 1930s. At the far right is Sally Keith, who performed regularly at the Theatrical Bar nightclub in the venerable Crawford House, located in the middle of Scollay Square. Sally Keith was a Chicago native who perfected the ability to spin four tassels that had been strategically placed on her costume—one over each breast and butt cheek—at dizzying speed. She was unquestionably the star of Scollay Square from the late 1930s through the 1940s. On nights that Sally was on the road, the lights were said to burn a little dimmer in Scollay Square.

IMAGES
of America
SCOLLAY SQUARE

David Kruh

ARCADIA

First published 2004

Published by Arcadia Publishing,
Charleston SC, Chicago IL, Portsmouth NH, San Francisco CA

Printed in Great Britain

Library of Congress Catalog Card Number: 2004108185

For all general information, contact Arcadia Publishing:
Telephone 843-853-2070
Fax 843-853-0044
E-mail sales@arcadiapublishing.com
For customer service and orders:
Toll-free 1-888-313-2665

Visit us on the Internet at www.arcadiapublishing.com

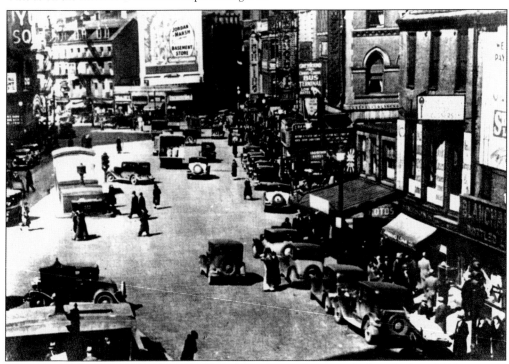

This view, looking northward into Scollay Square, was photographed in the late 1920s or early 1930s, when soldiers and sailors on leave, businessmen, high-school truants, Harvard students, housewives, and husbands flocked here for entertainment at places like the Crawford House, or for cheap eats at places such as Lun Ting's Chinese Restaurant, just down the block from the Crawford House (both on the right side of the street). Nothing shown here remains today. Even the streets were realigned when Scollay Square was razed in the 1960s as part of a massive urban-renewal effort by the city of Boston. If you were to stand in the same place today, 1-2-3 Center Plaza would be on the left, the John F. Kennedy Federal Building straight ahead, and city hall and City Hall Plaza on the right.

CONTENTS

ACKNOWLEDGMENTS

First, I want to thank Jennifer Durgin and Tiffany Howe of Arcadia Publishing for resurrecting my proposal for this book, and for giving me the opportunity to visually tell the history of Scollay Square in this, my second effort on Boston's bygone entertainment district.

The community of people who worked and played in Scollay Square is a generous one, and this book could not have been completed without the many contributions of photographs and memories. My deepest appreciations go to the following: Dave Lawlor for the sketches, memories, and photographs; Terry Mixon for the incredible images of her days at the Old Howard; Lilly Ann Rose; Katherine Fries (Lilly Ann's daughter), who is working hard to preserve her mother's memories; Susan Weis, who so generously provided her aunt Sally Keith's memorabilia; Carl F. Burgwardt for his expertise on bicycles; Brad Dalbeck and Chris Damian, from the wonderful Scollay Square Restaurant, for their enthusiasm and assistance; Ken Gloss of the Brattle Bookstore for the use of his photographs; James Calogero for allowing me to read his recollections of the Old Howard; Dick O'Brien for all the postcards; Gretchen Schnieder, who helped bring back Scollay Square, if only for day; Kristen Swett of the Boston Redevelopment Authority; former West Ender (and current friend) Joe LoPiccollo for the use of his collection; Elaine Kantor Whitener, whose family owned the Crawford House, for sharing with me her family memorabilia; and Frank Cheney and Anthony Samarcco, two prolific chroniclers of Boston history, for help with images. I especially want to thank Aaron Schmidt of the Boston Public Library, and Nancy Richard of the Bostonian Society, two keepers of the city's treasured past, who extended themselves to help make this book possible.

My gratitude goes to my family for encouragement and support in this and other endeavors. Thanks Mom, Dad, Bud, and Margo. Mauzy, I love you madly. To my daughter, Jennifer, keep dreaming, sweetheart . . . and always dream big.

—David Kruh
June 2004

For more stories, memories, images, and an interview with the author, as well as priceless recordings of Sally Keith, visit www.joeandnemo.com.

INTRODUCTION

To the tiny Shawmut Peninsula in 1630 came some of Boston's first immigrants—English men and women seeking refuge from religious persecution. What they found was a land that was harsh, but brimming with opportunity. By the time of the American Revolution, the tangled confluence of Tremont, Court, and Brattle Streets at the base of Boston's Cotton Hill had, by virtue of its location, become a transportation nexus and a cauldron of business activity, in a town whose harbor was the busiest port in North America.

Prominent in the center of this frenetic commercial activity was a collection of buildings purchased in 1795 by a Scottish apothecary named William Scollay. Scollay's father had been in the Sons of Liberty, and his grandfather, who immigrated to Boston from the Orkney Islands in the late 1600s, had operated the Winnisimmet Ferry. William moved into one of the buildings, and rented out the rest to various businesses. He also used the privilege of ownership to name the building after himself. Lacking any official designation for this part of Boston, the populace got into the habit of using Scollay's Building, which dominated the intersection, as a reference point. So did the operators of the horse-drawn stagecoaches and carriages that dropped off and picked up passengers nearby. Thus was born "Scollay's Square," or "Scollay Square," the designation made official by the city of Boston in 1838.

Beginning in the 1840s, Scollay Square—like the rest of Boston (and other cities and towns along the eastern seaboard) —groaned under the influx of Irish immigrants who had fled the potato famine in their homeland. Squeezed into lower-rent districts such as the North End and Fort Hill, the new immigrants made their presence felt in Scollay Square, whose businesses had heretofore served the more established—and wealthy—Yankee clientele. As businesses adapted to their new customers, the character of the area changed. Soon sailors on leave, dockworkers, and shipbuilders were flocking to Scollay Square, seeking inexpensive places to eat. They were joined by businessmen from downtown office buildings, and government workers from the state house (just up Beacon Hill), the courthouse (down Court Street), and city hall (behind the courthouse on School Street). Housewives and domestics shopped for everything from tea to clothing. Despite the influx of even more immigrants pouring in from dozens of other countries, this part of town became a destination for travelers because of the square's fine hotels, including the Crawford House, Young's Hotel, and the Quincy House. Through the square, wrote one guidebook of the day, "flow the deepest and most agitated currents of humanity."

Shopping, eating, and sleeping were not the only things to do in Scollay Square, of course. In 1845, the Howard Athenaeum opened to rave reviews with a performance of *The Rivals*. A fire burned down the original wooden theater just three months after opening night, but the owners, encouraged by the strong box office, built a glorious new building in Quincy granite, which for many years provided a steady diet of drawing-room comedies, Shakespeare, Mozart, Verdi, and the classics. But with the Brahmins removing themselves to more socially appealing

neighborhoods such as the Back Bay, and with the new residents of Boston showing little interest in Mozart or Verdi, the owners of the Howard Athenaeum were forced to change the bill of fare to a new form of entertainment that was sweeping the country: burlesque. This burlesque was not the art form practiced in the 1920s by baggy-pants comics and limber young women, but was rather a collection of skits, songs, jugglers, dancers, and actors presented in something akin to a variety show. With seats in the upper gallery costing just 15¢, the Howard once again became a local favorite.

The success of the Howard Athenaeum (and the nearby Boston Theater on Tremont Street) did not go unnoticed by other would-be impresarios, and in the late 1800s, other venues opened in Scollay Square that presented burlesque, as well as a new form of entertainment known as vaudeville. To keep up with the competition from motion pictures and then radio, burlesque and vaudeville both evolved into the more frenetic, risqué entertainment memorialized in movies such as *Gypsy*. The navy yard in Charlestown, just a short ride away by trolley or subway, provided scores of sailors and shipbuilders eager for the inexpensive good times in the square. By the 1920s, Scollay Square had completed its evolution from a commercial and transportation hub into the entertainment center for which it gained worldwide fame. Nightclubs and bars proliferated in the area, likewise speakeasies during the dark, dry days of Prohibition. With the repeal of the Volstead Act in 1933 (ending Prohibition) and the onset of World War II in 1941, Scollay Square crackled with activity.

The end of World War II brought a reduction in navy yard activity and the migration of increasingly affluent city dwellers to the suburbs. These trends, along with the gross political incompetence and malfeasance of Mayor James Michael Curley's final administration, caused hard times in the city of Boston. Scollay Square was especially hard hit, and it fell into blight. Desperate to disprove *Fortune* magazine's 1964 description of Boston as "dying on the vine," and with millions of dollars in federal money available for "urban renewal," the city targeted the square for redevelopment as a new Government Center. When the dust had cleared, Boston had a shining new—if not peculiar—city hall, as well as a promising future. Precious little remains of the place that made truants of many New Englanders, save for a couple of buildings, some menus, playbills, postcards, and photographs.

This book, then, is a look back at the history of the tangled confluence of streets at the base of Cotton Hill—from the days of John Winthrop and Patrick Tracy Jackson, to the nights of Sally Keith and Ann Corio, and beyond.

One
THE EARLY YEARS

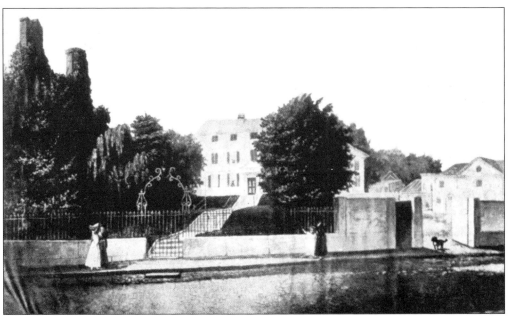

The home of Gardner Greene stood at the base of Cotton Hill, and behind it was a beautiful terraced garden filled with imported plants, animals, and greenhouses filled with exotic plants. In 1832, entrepreneur Patrick Tracy Jackson bought the property, demolished the home, and literally removed Cotton Hill. In its place, he create a beautiful new neighborhood known as Pemberton Square. (Courtesy Bostonian Society–Old State House.)

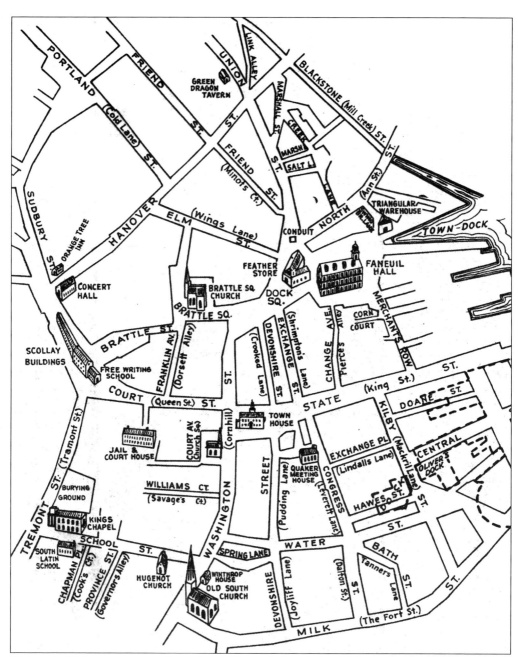

This early-19th-century map, from Anna Thwing's *Crooked and Narrow Streets of Boston*, shows many landmarks within the area that was already known as Scollay's Square. Scollay's Buildings can be seen dominating the intersection of Court, Brattle, and Tremont Streets. Other Scollay Square landmarks include the Brattle Square Church, the Concert Hall at the head of Hanover Street, the Orange Tree Inn (just across the street from the Concert Hall), and the site of the Free Writing School, the second public school in Boston. In 1816, a new street was carved out between Brattle and Court Streets to provide a shortcut from Cotton Hill to Dock Square. The street was first called Cheapside, then Market Street, and in 1829 it was given the name Cornhill, which up to that point had designated the northern portion of Washington Street, as seen here.

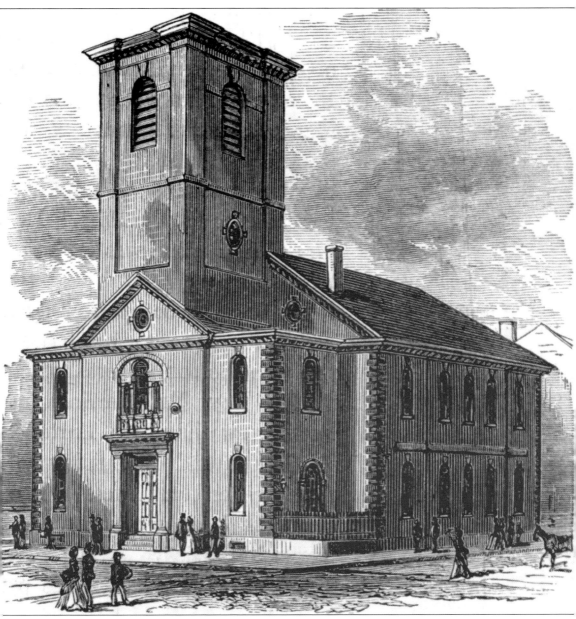

In 1697, Thomas Brattle gave a portion of his family's land near Dock Square to a group of people who had broken away from the dominant Puritan church. The wooden structure they first built was known as the Manifesto Church. In 1772, the church was rebuilt in stone, with a new bell as a gift from John Hancock. The church likely survived because of this structural change, because British soldiers later used many wooden churches for firewood. During the siege of Boston, the soldiers used the church as a barrack. The dark circle above and to the right of the front door is a cannonball that hit on the evening of March 16, 1776, the night before the evacuation of Boston. The church was not a target, of course—British soldiers quartered in other buildings in the square were the intended victims. The role the Brattle Square Church played in the evacuation led Oliver Wendell Holmes to compose the following couplet: "Wore on her bosom as a bride might do, the iron breastpin the rebels threw."

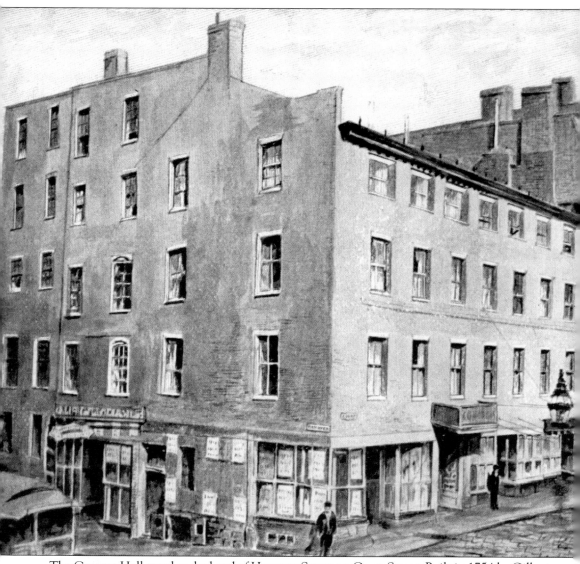

The Concert Hall stood at the head of Hanover Street on Court Street. Built in 1754 by Gilbert Deblois, the organist at King's Chapel, the hall survived until Hanover Street was widened in 1869. As the name suggests, the Concert Hall served as a venue for concerts and musical events. (Consider that it was only 20 years earlier, in 1731, that the first publicly announced concert comprised of material other than "sacred" music was held here in Boston.) The large hall was also used regularly by the Grand Masons, the Society of Cincinnati, and other fraternal groups for meetings. In 1778, Gov. John Hancock held a grand ball here in honor of Count D'Estaing and the officers in his fleet. On the opposite side of Hanover Street, from 1712 until 1798, was the popular Orange Tree Inn, along with the starting point for the stagecoach to Newport, and the site of the first hackney, or taxi, stand in town.

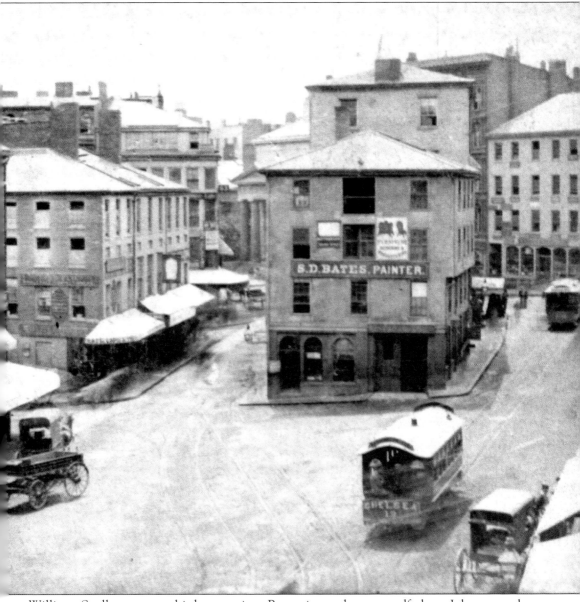

William Scollay was a third-generation Bostonian, whose grandfather, John, ran the Winnisimmet Ferry, and whose father, also named John, was one of the city's first fire wardens and a selectman during the British siege. William, an apothecary by trade, had a shop on the northern part of Washington Street, which was then known as Cornhill. William also liked to dabble in real estate. He once entered into a unique partnership with Charles Bullfinch and another man for the construction of a series of buildings on Franklin Street that, due to the men's financial arrangement, became known as the Tontine Crescent. In 1795, William purchased from Patrick Jeffrey a row of buildings Jeffrey had built several years earlier in the center of Court Street, near its intersection with Tremont. William, who had been living on Tremont Street near King's Chapel, moved into the upper floor of the building closest to Tremont (and farthest away from the viewer in this mid-1800s photograph), and rented out the rest of the buildings to businessmen and retailers. (Courtesy Boston Public Library.)

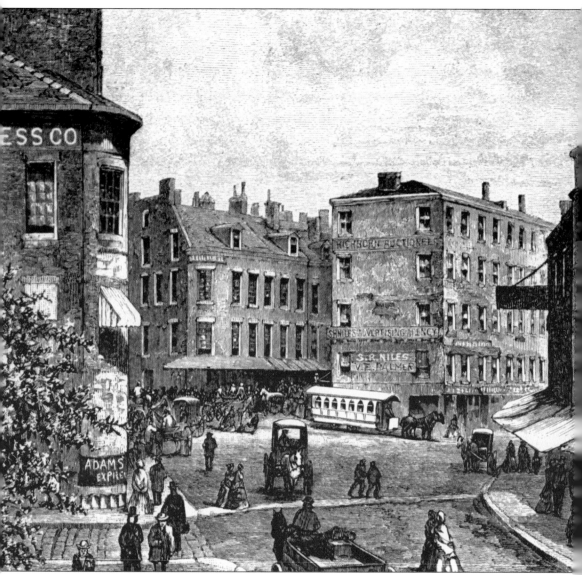

This 1850 view looks up Court Street from the courthouse (Court Square, the street surrounding the courthouse, can be seen in the lower left) toward the Scollay Building, which had been purchased by William Scollay in 1795. Note the horse-drawn trolley making its way past the Scollay Building. The stagecoach drivers, lacking any official name for this centrally located intersection convenient to the business district, Beacon Hill, and the docks, got into the habit of announcing the stop as Scollay's Building or Scollay's Square. This designation was so widely used that in 1838 the city of Boston officially named this intersection Scollay Square.

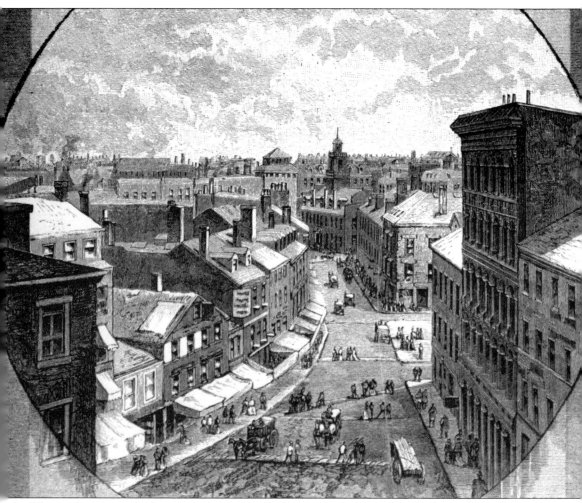

This etching reveals the opposite view as the previous image, and looks down Court Street toward the Old State House. A corner of the Scollay Building can be seen at the lower left. In 1854, Court Square, on the right side of the street, about halfway to the Old State House, was the site of the Anthony Burns riot. Burns was a slave who had escaped from his Virginia master and come to Boston, only to be arrested under the Fugitive Slave Act. While Burns was held at the courthouse, a large crowd gathered on Court Street and attempted to block his return to Virginia. Despite the protesters' efforts, Burns was returned to his owner. However, a black church later raised $1,300 to purchase Burns's freedom, and in less than a year he was back in Boston.

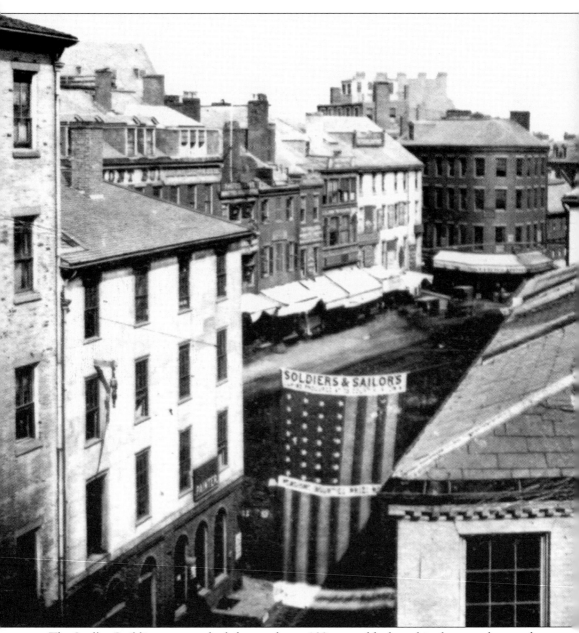

The Scollay Building, seen at the left, was almost 100 years old when this photograph was taken around the time of the Civil War. The image is filled with fascinating details, such as advertisements adorning the fronts of the buildings on Tremont Row, and horse-drawn delivery carriages moving along Court Street. On the third floor, above the fourth window from the right, built into the wall there is a pulley that was used for hoisting heavy objects. Hanging between the Scollay Building and a building across the street is an American flag adorned with a message the appears to be some kind of recruitment poster for the war. Even back then, Scollay Square was a magnet for servicemen. (Courtesy Boston Public Library.)

Taken around the time of the Civil War, this southward view from Scollay Square looks down Court Street. The Old State House is down the block, just beyond the American flags. Seeking a better view of the parade, a man has gone up onto the roof of the second building on the left side of the street (just above the sign that advertises umbrellas and parasols).

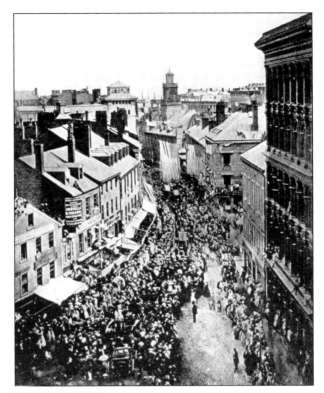

The Ancient and Honorable Artillery parades on Brattle Street in the mid-1800s. The Brattle Square Church stands at the end of the street. According to Samuel Adams Drake in *Old Landmarks and Historic Personages of Boston*, the row of granite buildings on the left (or north) side of the street was the first block of stone buildings erected in Boston.

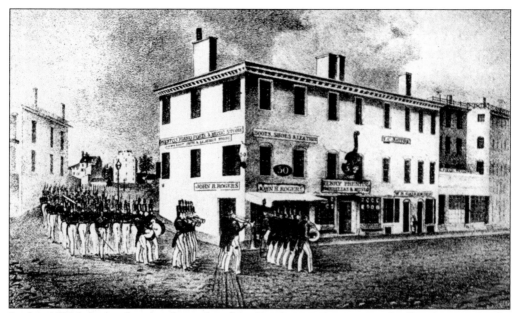

In this 1833 lithograph, a band marches from Pemberton Square into Scollay Square. At the same time that he built Pemberton Square, Patrick Tracy Jackson also built Tremont Row—a collection of shops, boutiques, and offices (including that of Boston's first dentist and photographer). Also located there was the Papanti Dance Studio, a place where America first learned to dance the waltz and Charles Dickens read from his *Pickwick Papers*.

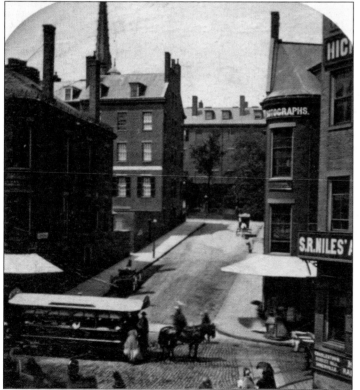

A horse-drawn trolley stops in Scollay Square to take on a passenger in this Civil War–era photograph. The corner of the Scollay Building can be seen at the right. Just across the street and up the small hill is Pemberton Square, where at one time almost half of the millionaires in New England lived. (Courtesy Boston Public Library.)

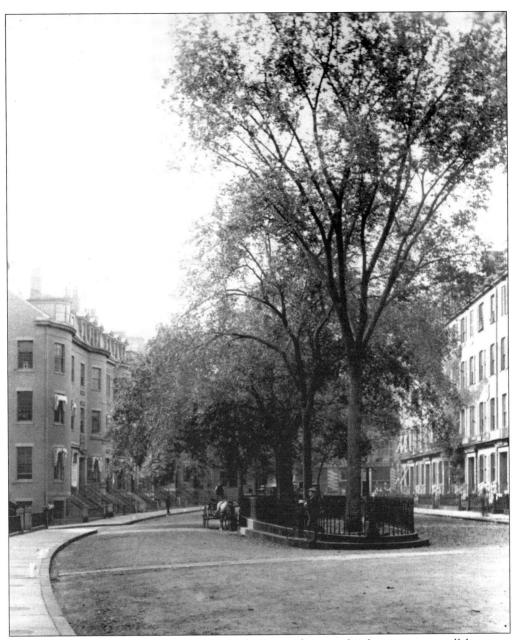

Pemberton Square, with its fine bow-front homes and center landscaping, was still home to some of Boston's Brahmin class when this photograph was taken, sometime after the Civil War. But the frenetic activity of Scollay Square, just down the street to the left, had begun to insinuate itself into the neighborhood, as evidenced by the Houghton & Dutton Home Goods Store in the building at the far end of the square. The bicycle in this image was called an "ordinary" or "high" bicycle, which, according to Carl Burgwardt of the Pedaling History Bicycle Museum in Orchard Park, New York, was made between 1870 and 1892. In the 1920s, Burgwardt says, those bicycles "were looked back on and referred to as penny-farthings," because the wheels were the comparative size of the English penny and farthing. (Courtesy Boston Public Library.)

The proximity of Pemberton Square to the state house and city hall would be its undoing when, following the Civil War, it was chosen as the site for a new courthouse, shown here in a c. 1910 postcard. According to the Web site on the courthouse's ongoing renovation, construction took a long time due to political infighting, arguments over funding and design, and labor troubles.

This courthouse postcard dates to c. 1910. According to the Web site about the building's renovation: "Architect George Clough was called in again to modify his original structure in 1909 and 1910 because of the need for more space. His plan called for . . . two more stories in the form of a large mansard roof placed on top of the building."

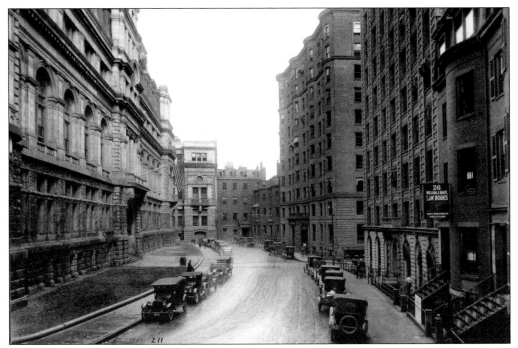

When the courthouse was finished in 1894, it was the largest in Massachusetts, and housed the Massachusetts Supreme Judicial Court, the Boston Municipal Court, and the Social Law Library. Many attorneys were attracted to the area, and set up their offices here. This photograph from the 1920s shows that most of the original 1832 bow-front homes have been replaced by office buildings. (Courtesy Boston Public Library.)

From 1883 to 1925, the Boston Police Department was headquartered at 37 Pemberton Square. The proximity of the headquarters (shown here in 1890) to Scollay Square and the state house would figure into the events of the 1909 Boston police strike, when fears of anarchy spread through the city. From his headquarters here, police Chief Edwin Curtis would command action to restore order to the city. (Courtesy Boston Public Library.)

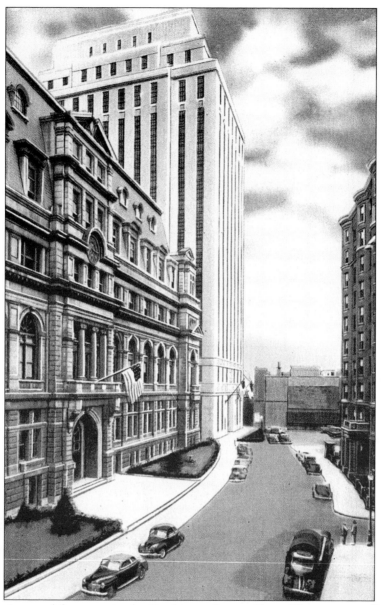

"The increasing need for space in the Pemberton Square Court House eventually led to the construction of the 'New' Suffolk County Court House in 1936–1939," according to the Web site on the courthouse renovation. Both the new and old courthouses are shown in this 1940 postcard image. "Many plans were suggested, all trying to accommodate the needs of the courts and other offices in the building. The Great Depression, however, slowed down all new construction work in the early 1930s. It was the Federal Emergency Administration of Public Works that eventually took charge of the construction. The architectural firm of Desmond & Lord designed an Art Deco tower that would sit next to the 'Old' Court House and be attached through several connecting layers. For a while, there were fears that the Tower would overshadow the dome of the State House, until then the highest building on Beacon Hill. But the Tower was built and the courts moved in during 1939, just as the United States was nervously watching the outbreak of World War II."

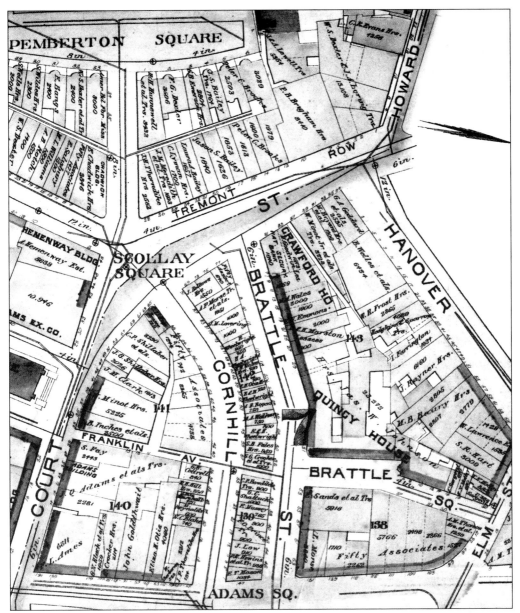

This official city map from 1886 shows the ward in which Scollay Square was located. Peruse the buildings, streets, alleys, and smaller squares that together make up the area called Scollay Square, and you can see that each building is marked with its street number and its owner or owners. The locations of gas mains are also shown. Howard Street and the Howard Theatre are visible in the upper right-hand corner, while Franklin Avenue, really a narrow alley, can be seen running between Court Street and Cornhill on the left.

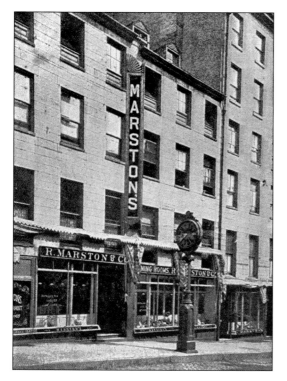

When Russell Marston opened his restaurant here on Brattle Street in 1847, it seated only 20 people. By 1895, when this photograph was taken, the eatery had expanded to one of the biggest in Boston, boasting a seating capacity of more than 800. One guidebook reported, "The pleasant and well-conducted Marston restaurants are constantly patronized by the best people of Boston and all New England."

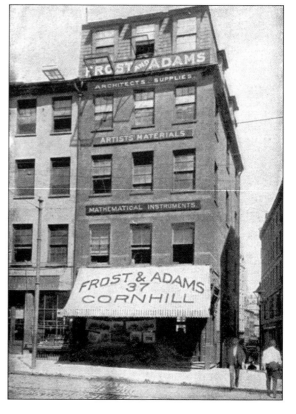

By the time this photograph was taken for an 1895 guidebook, Frost and Adams had been in business at 37 Cornhill for more than 50 years. The store was described as having "an immense and varied stock of artists' and architects' materials, mathematical instruments, and articles for decorating. They import largely from Europe, and have extensive trade all over America."

This early-20th-century photograph, taken from the balcony of the Old State House, shows the Ames Building, which at the time housed banks, offices, and trust companies. When it was finished in 1889, the 13-story, 190-foot-high structure was the tallest in Boston. It had been built at a cost of $700,000.

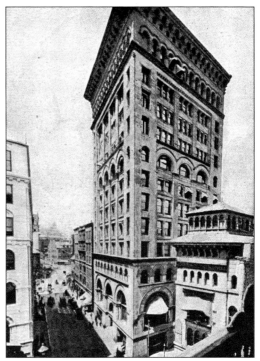

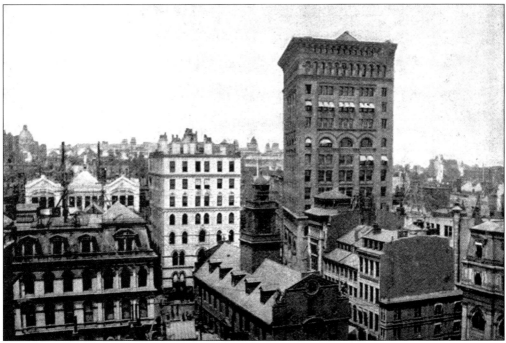

A plaque at the base of the Ames Building reads: "The 13-story Ames Building was the tallest building in Boston when it was completed in 1889. Constructed before skyscrapers were built of steel, the Ames Building is separated by 9-foot-thick masonry walls. The Roman-esque style building was designed by Shepley, Rutan, and Coolidge. The Ames Manufacturing Company supplied shovels to build Civil War fortifications and the transcontinental railroad."

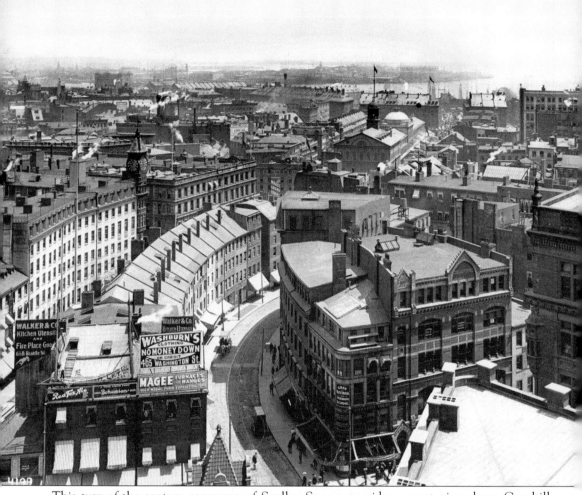

This turn-of-the-century panorama of Scollay Square provides a great view down Cornhill, which had been a hotbed of abolitionist activity in the years leading up to the Civil War. At the lower end of Cornhill near Washington Street, William Lloyd Garrison published his *Liberator* magazine. It was also here on Cornhill that Emerson, Whittier, Thoreau, and others met to plan the anti-slavery movement. What took place at Cornhill was not just talk, however. In the basements of some of these buildings were hiding places for runaway slaves, making Scollay Square a stop on the Underground Railroad. (Courtesy Boston Public Library.)

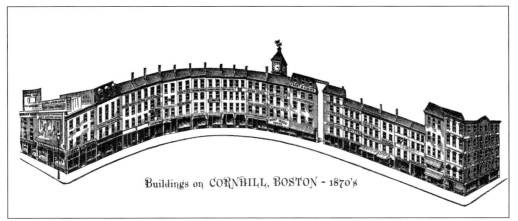

Buildings on CORNHILL, BOSTON - 1870's

This splendid etching details the businesses that occupied Cornhill during the 1870s. These establishments included purveyors of tea, window shades, kitchen furnishings, dining room furniture, books, tables, desks, sieves, screens, art materials, chairs, and trunks, as well as guns, rifles, and fishing tackle. Sign painters, house painters, and wallpaper hangers also set up shop in this part of Scollay Square. (Courtesy Boston Public Library; etching by T. J. Lyons.)

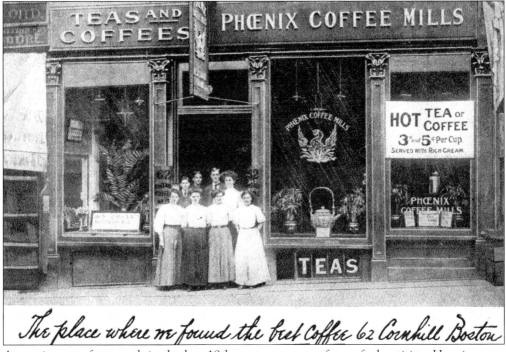

The place where we found the best Coffee 62 Cornhill Boston

A growing use of postcards in the late 19th century was as a form of advertising. Here is a very clever bit of promotion by the owners of the Phoenix Coffee Mills on Cornhill. The cursive writing on the bottom of the card was not written by the postcard's sender, but rather was printed as part of the card itself.

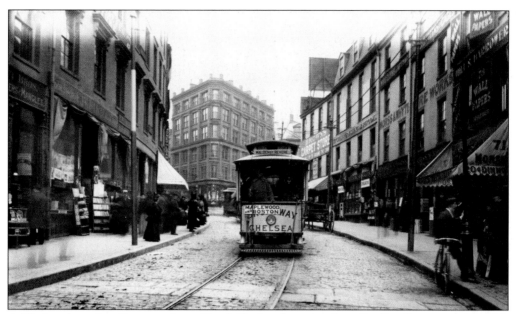

A Chelsea-bound trolley runs down Cornhill after departing from Scollay Square on April 14, 1897. On the left side of the street stands one of the many bookstores that populated Cornhill. We can thank the Boston Elevated Railroad Company for its fastidious recordkeeping and photographing during subway construction, providing us this and the other images of the square featured in Chapter 2.

Cornhill became home to a number of small publishers, many of whom specialized in volumes of fiction and poetry. *The Cornhill Booklet*, written and published by Eugene Field, contained a number of short pieces such as "A Fire," which reads: "Is this a fire? No, it is not a fire. It is a Judge of the County Court. Why did you think it was a fire. Because it looked so Red."

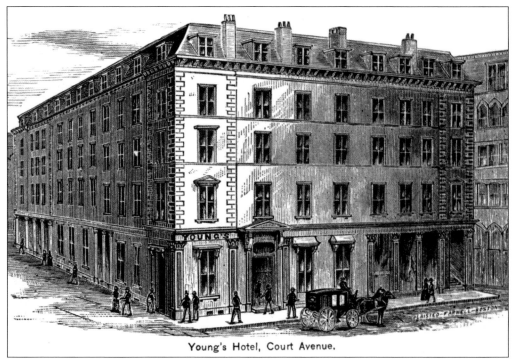

Young's Hotel, Court Avenue.

First opened in the mid-1800s by George Young, who named the hotel after himself, Young's was one of several hostelries in Scollay Square that were held in high regard. According to the 1878 edition of *King's Handbook of Boston*, "The prices of lodging range from $1 to $3, according to location of room."

King's Handbook described Young's Hotel, shown here in an early-1900s postcard, as "patronized almost exclusively by men; and is a great resort of clubs, for whose accommodation there are twelve club rooms. . . . In 1878 extensive renovations were made . . . a new and elegant restaurant, billiard-room, and café were added; an elevator was put in; and well-appointed reading-rooms, wash rooms, barber-shop, bath-rooms, newspaper and theater-ticket stands, and telegraph office were opened."

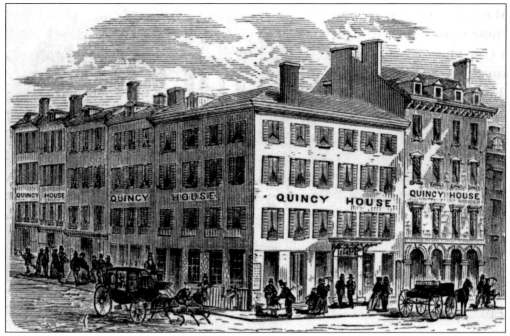

The Quincy House was the first building in Boston to be constructed with, as the name suggests, Quincy granite. Located at the corner of Brattle Street and Brattle Square, on the site of the first Quaker meetinghouse, the hotel was expanded on a number of occasions. In 1878, the year this etching was made, patrons paid just $2.50 for a night's stay.

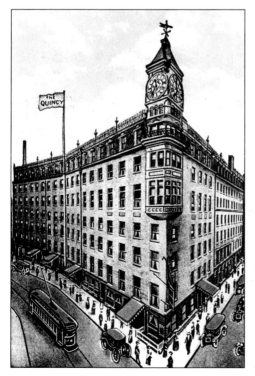

In an era when cameras were still expensive and heavy affairs, postcards were an easy and cheap way for people to share vacation memories. In this early-1900s postcard image, an electric trolley heads down Brattle Street past the main entrance of the Quincy House. Motorcars, still a relatively new invention, stop to drop off and pick up passengers.

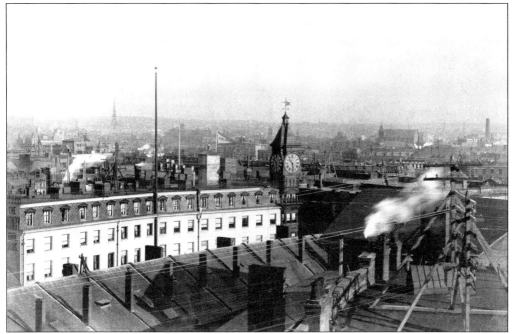

The spire of the old North Church can be seen in the distance of this 1901 aerial view, which looks northwestward from Scollay Square. The long white building is the Quincy House, which stretched halfway along Brattle Street. Note the mass of telephone and telegraph wires that run from the poles fixed to the roof in the foreground. (Courtesy Boston Public Library; photograph by Baldwin Coolidge.)

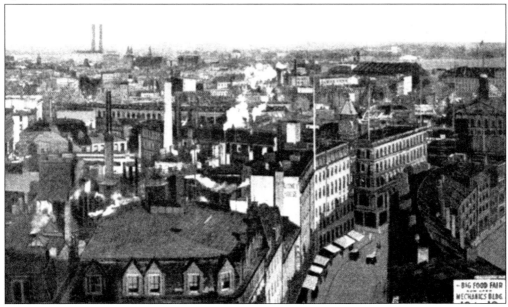

At the head of Brattle Street, the roof and upper floors of the Crawford House are visible in this c. 1900 postcard. Farther down the block is the Quincy House, notable for the impressive clock tower that dominated Brattle Square. Follow the curve of Brattle to the waterfront and see Faneuil Hall, behind which is the dome of Quincy Market.

Hanover Street's American House was described in *Bacon's Guidebook* as "the largest public house in New England, and one of the best. Its external appearance has been very greatly improved by the recent widening of Hanover Street. The interior has also been completely remodeled within a few years, and many of the rooms are exceedingly elegant, while the furniture of the house is throughout handsome and substantial."

Near Scollay and Adams Station of Subway, Boston, Mass. Rooms $ 1⁰⁰ per day and upwards

New American House

This postcard of the American House on Hanover Street further accentuates the hotel's charm. According to *Bacon's Guidebook*, "The grand dining room is an immense hall, capable of seating at one time more than three hundred people; when lighted at night it is one of the most brilliant halls in Boston, having at either end mammoth mirrors reaching from the floor to the ceiling."

Two

THE SCOLLAY SQUARE SUBWAY STATION

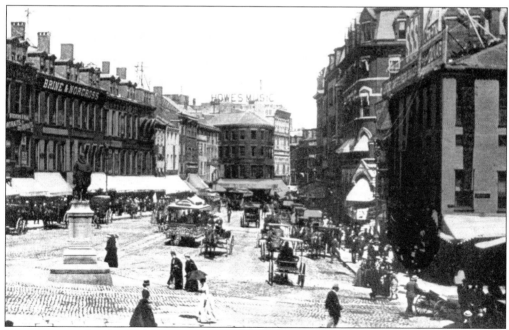

In preparation for the 250th-anniversary celebration of the founding of Boston, the board of aldermen approved the expenditure of $5,000 for a bronze copy of the marble statue of Gov. John Winthrop. The original statue, sculpted by Richard Greenough, sat in the rotunda of the United States Capitol. In this northward view into the square, Tremont Row stretches along the left side of the street.

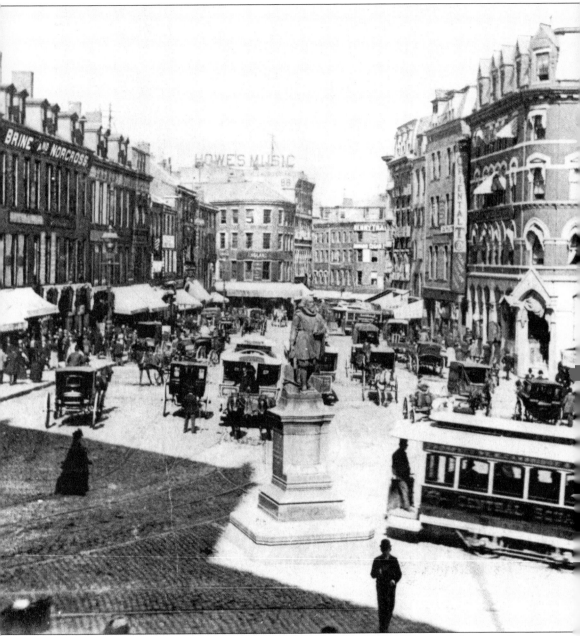

By the time this photograph was taken in 1888, the construction of the courthouse in Pemberton Square (just behind Tremont Row, on the left side of the image) was destroying the last vestiges of the genteel residential neighborhood planted by Patrick Tracy Jackson 50 years before. The square itself had also been transformed into a bustling commercial center, thanks in great part to the changes brought by the Irish and other immigrants. That the city would place the statue of so notable a citizen as John Winthrop here speaks volumes about the status of Scollay Square as a proud part of Boston's commercial district during this era.

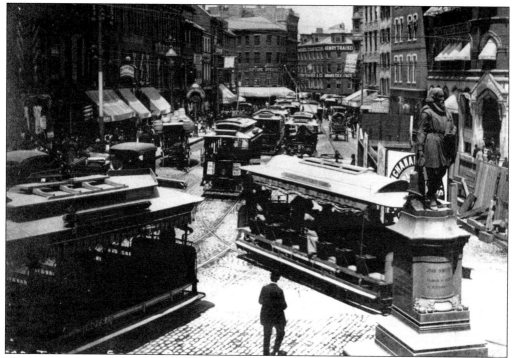

Electric trolleys jam Scollay Square on June 2, 1896, demonstrating clearly the traffic problem that led Boston to begin construction of the nation's first subway system. On the right side of the street, just before the Crawford House, is the wooden support structure for construction crews digging the tunnel below. At the lower right is the Governor Winthrop statue.

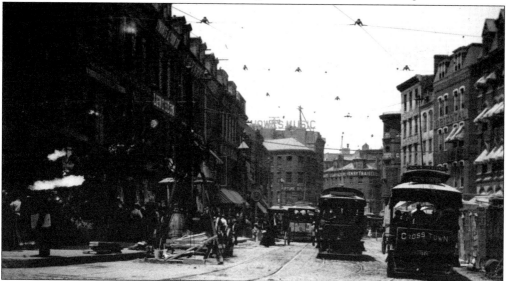

Construction on the new subway progresses underground on July 9, 1897. As Boston learned during the "Big Dig" a century later, perhaps the toughest—and most expensive—challenge when building in a working city is trying to keep traffic (in this case electric trolleys and horse-drawn carts and carriages) moving through the construction zone, and keep doors and loading docks free and clear.

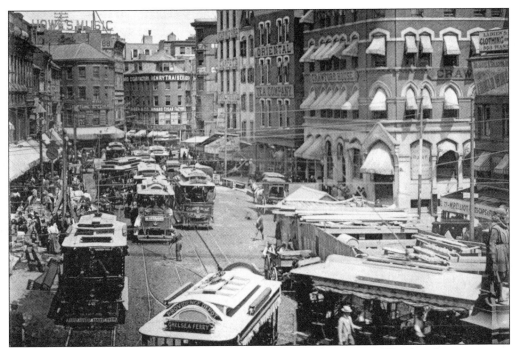

This July 15, 1897 photograph is the last-known image of Governor Winthrop's statue in its original location in Scollay Square. The statue appears at the lower right. This scene provides evidence of the tremendous traffic problems caused by the crush of electric trolleys on Boston's narrow streets, circumstances that inspired the construction of the subway system.

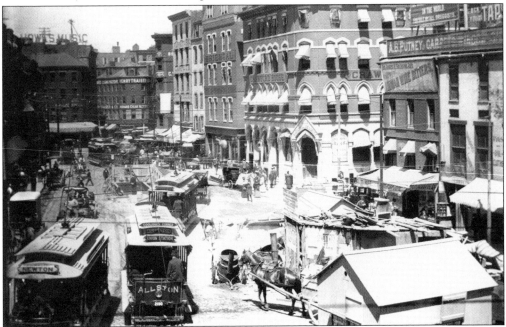

Here on August 13, 1897, the Governor Winthrop statue has been moved to make way for the construction of the subway kiosk. A foreman's office has been built on the eastern side of the square, which is seen on the lower right side of the photograph.

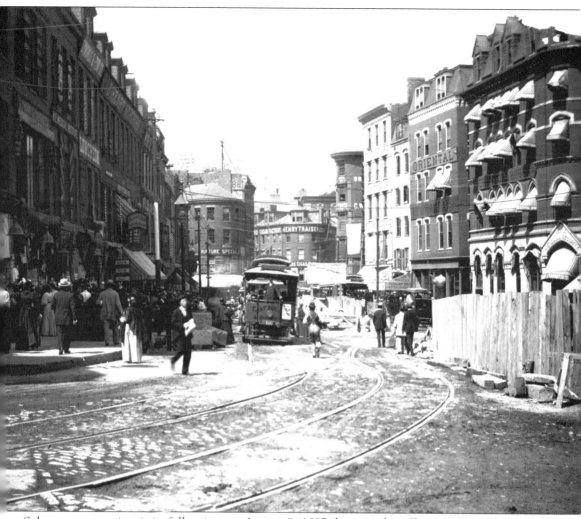

Subway construction is in full swing on August 8, 1897, but people still swarm into Scollay Square to eat, bank, and shop for items as diverse as furniture, cigars, and carpeting. A trolley bound for East Boston and Chelsea has stopped to pick up and drop off passengers in front of Tremont Row. Meanwhile, across the street, the original steaming kettle, releasing a puff of smoke from its spout, hangs over the front door of the Oriental Tea Company.

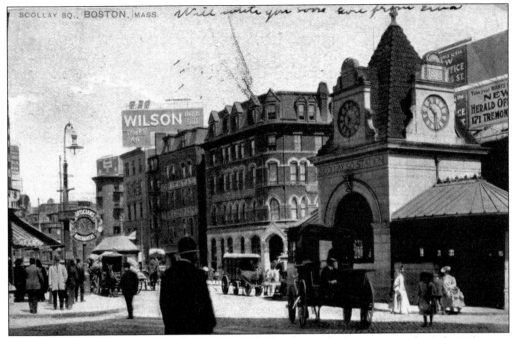

This postcard features the new subway kiosk, which, like its duplicate in nearby Adams Square, was designed by Charles Brigham. The initial stretch of subway, from Park to Boylston Streets, opened on September 1, 1897.

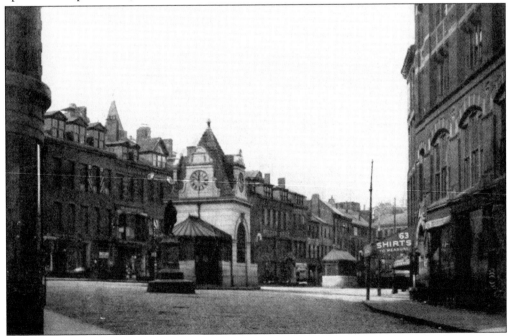

Photographed at the turn of the century, this view from the old courthouse looks up Court Street toward the subway kiosk. Behind the kiosk are the buildings of Tremont Row. The construction of the subway in Scollay Square and the placement of the kiosk in the middle of the street forced the city to move the John Winthrop statue down Court Street about 50 feet.

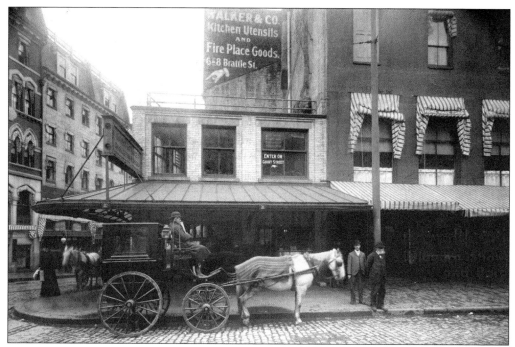

The east side of Court Street is shown here, at the corner of Brattle Street, on May 27, 1901. According to historian Frank Cheney, the building pictured was owned by the Boston Elevated Railroad and was the office of Division 8, responsible for downtown operations. On this site later came the Pen and Pencil Club, "a rather notorious watering hole for show people, members of the press, and assorted bohemian types."

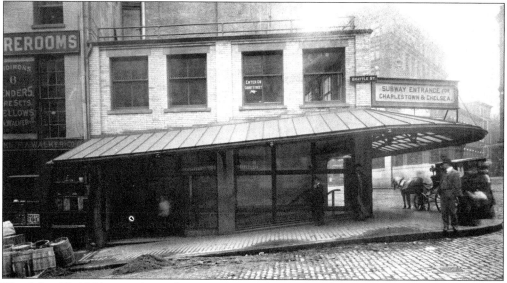

This May 27, 1901 view shows the same corner depicted at the top of the page, but from the direction of Brattle Street toward the Scollay Square kiosk. "The Scollay Square Station had a separate platform for cars bound for Everett, Somerville, Malden, Chelsea, and Lynn. This platform was called Brattle, since it had its one entrance stairway," states Frank Cheney. Outside the station, horse-drawn carriages—hacks—wait for fares.

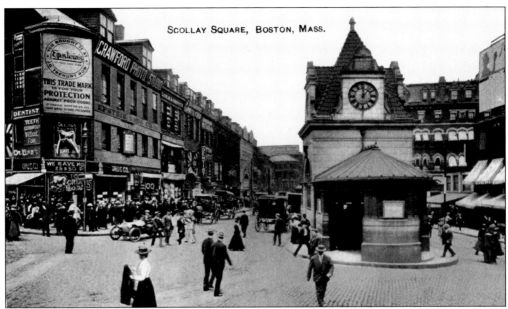

SCOLLAY SQUARE, BOSTON, MASS.

Scollay Square is shown in all its bustling glory in this northward view, photographed sometime between 1906 and 1911. Epstein's Drug Store, a landmark in the square for more than 60 years, stands at the corner of Pemberton Square, at 26 Tremont Row. Owner Julius Epstein, born in Medford, grew up in Revere Beach and went on to own a number of businesses in Scollay Square, including Avery Photo Studios.

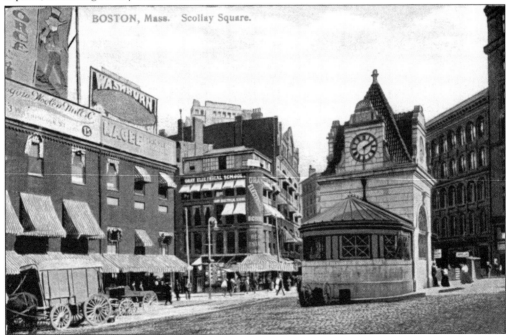

This view from Tremont Row shows the back of the kiosk. A horse-drawn cart, seen here on Court Street, was still the primary means of delivering goods at this time. Just beyond the kiosk, down Court Street, construction has begun on a stop for a new subway line from East Boston's Maverick Square.

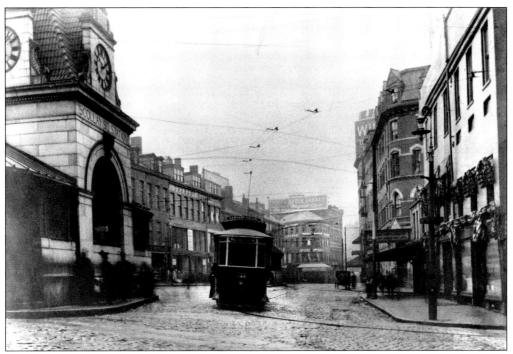

Even after the completion of the subway in 1898, trolleys still traversed the surface of several streets in Scollay Square. In this 1906 northward view, a trolley makes its way past the new kiosk. Across the street is Tremont Row.

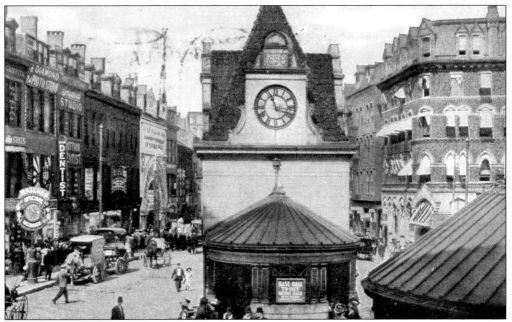

In the 1840s, Tremont Row was home to William Thomas Morton, the first dentist to use anesthesia, and Josiah Hawes, one of Boston's first daguerreotypists, or early photographers. As evidenced by this and other images of Tremont Row, the street never lacked for dentists or photographers.

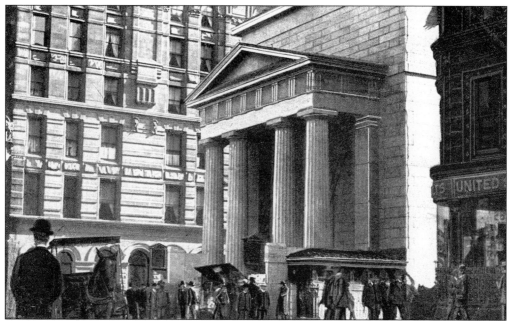

The new Court Street entrance to the East Boston line can be seen on the right side of the old courthouse. According to Scott Moore, on the 100 Years of the Tremont Street Subway Web site: "This tiny station was built to facilitate the turning of cars from East Boston. Connecting stairways and passages were constructed to facilitate transfers between Court Street and Scollay."

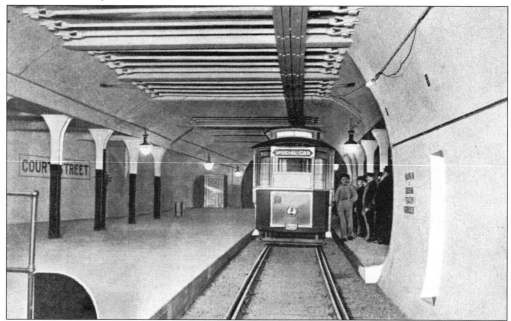

The Boston subway system was a marvel, and the stations along both the Tremont Street and East Boston lines were the subject of several postcards. Soon after opening on December 30, 1904, this postcard was made of the Court Street station, the end-of-the-line stop for the first underwater subway built in the United States.

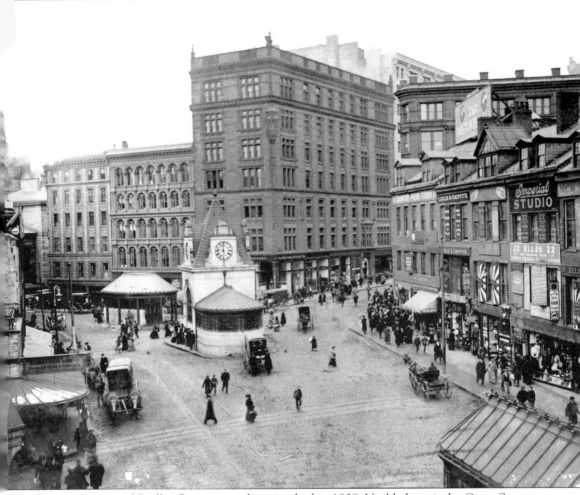

This terrific view of Scollay Square was photographed in 1908. Visible here is the Court Street exit kiosk for the East Boston line, the construction of which had forced the retreat of Governor Winthrop's statue from the square. (In 1912, the East Boston line was extended to Bowdoin Square, with the tunnel passing under the existing Scollay Square station. It still runs today as the subway's Blue Line.) Not a single motorcar can be seen on any street; horse-drawn carts and buggies still dominate. A little more than a decade later the reverse would be true, as the automobile would take over Boston and force further changes to Scollay Square and the kiosk. (Courtesy Boston Public Library.)

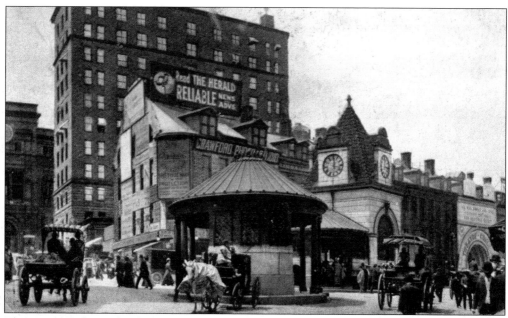

The completed exit kiosk for the new Court Street station of the East Boston subway line opened in 1904. For the second time in six years, Governor Winthrop's statue was forced to move for a subway station. The Boston Board of Arts Commissioners relocated the statue to the front of First Church on Marlboro Street in the Back Bay. Winthrop, a founding member of that church, would have been pleased.

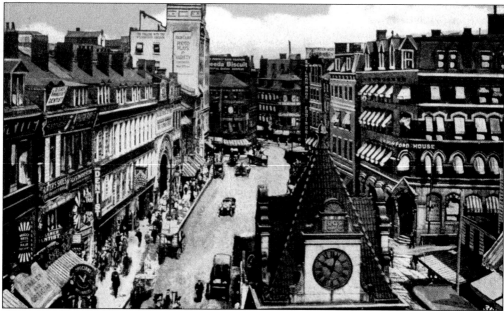

The reason for the proliferation of photographers and dentists in Scollay Square, shown here c. 1915, is the same reason why there were so many bars, theaters, and tattoo parlors here: the constant stream of servicemen on leave. They were always looking to have their photographs taken for family, friends, and sweethearts back home—and also in constant need of good, cheap dental care.

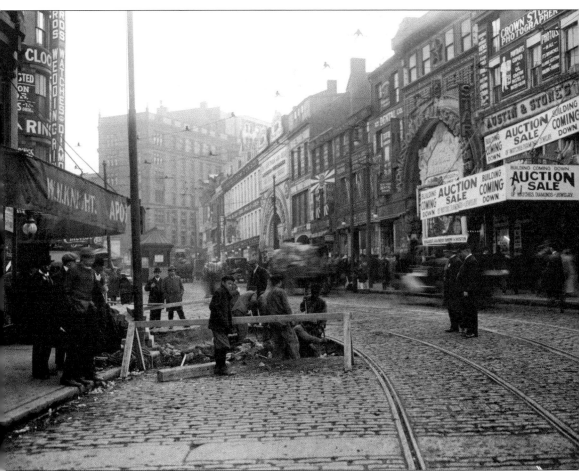

In the foreground of this November 29, 1912 photograph, construction continues on the aforementioned extension of the East Boston line from Court Street to Bowdoin Square and the tunnel under Cambridge Street that connected East Boston directly with Cambridge. (The Cambridge Street tunnel was later abandoned, and the Bowdoin Square stop on the renamed Blue Line was shut down, too, as part of a cost-cutting measure by the Massachusetts Bay Transportation Authority.) At the right side of the scene, Austin & Stone's Dime Museum on Tremont Row will soon be torn down to allow for the construction of Scollay's Olympia Theater. The dime museum, which was owned by P. T. Barnum, had been in operation for 30 years, and had been a competitor of the Boston Museum. Next door, the Star Theater advertises that it has recently installed a new technology for the amusement of its patrons: a movie projector. Farther down the street is the arched entrance to the Theatre Comique, which, when it opened in 1906, was the first theater in Boston built expressly for showing motion pictures.

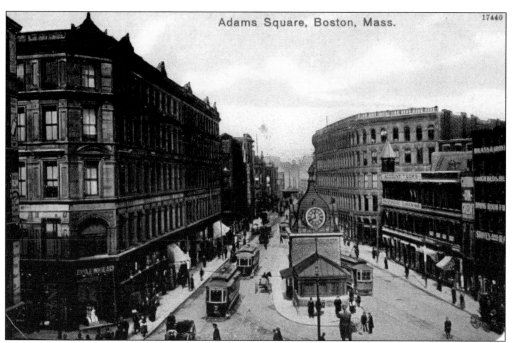

This is a postcard of Adams Square at the turn of the 20th century. Adams Square, located down Cornhill and Brattle Streets from Scollay Square, was another heavily commercial district that featured purveyors of dry goods and furniture. Establishments included the Leopold & Morse, seen at the left, which at the time was one of Boston's biggest stores.

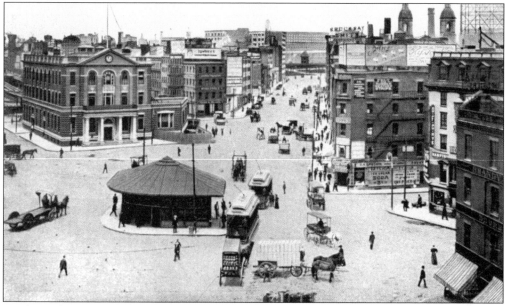

At the end of Washington Street, just outside Adams Square, was Haymarket Square. In this early-20th-century photograph, the viewer looks northward over the subway kiosk, with Adams and Scollay Squares behind him. In the distance, the elevated's Commercial Street stop can be seen. According to historian Frank Cheney, the Haymarket kiosk was originally expected to be temporary, but it remained in service for more than 35 years.

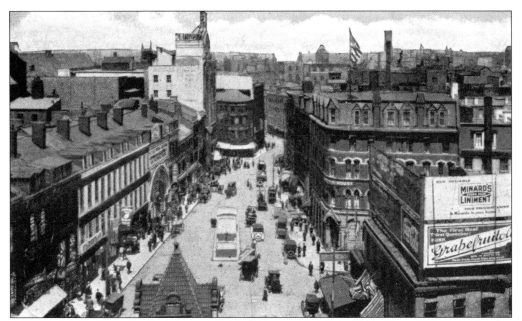

Woolworth's, the Theatre Comique, and the Star Theater all line Tremont Row in this postcard, made after the Scollay's Olympia Building (the tall tower at the end of the block) was constructed in 1912. The Olympia was built using steel-reinforced concrete, making it one of the first buildings in Boston constructed in such a manner.

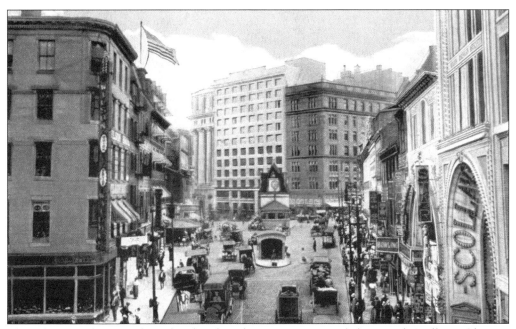

This photograph was taken shortly after the construction of the grand Scollay's Olympia Building in 1912. The façade of the Olympia can be seen on the right side of the scene. The large, white structure at the far end of Scollay Square is the United States Trust Building.

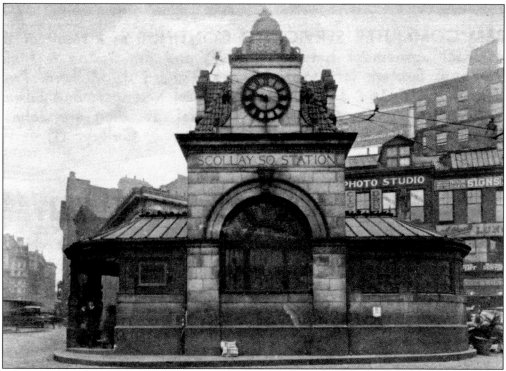

One of the last-known photographs of the Scollay Square subway kiosk, this image was taken in 1926, when the city was grappling with traffic congestion. Traffic conditions had grown worse due to increasingly affluent American consumers and the availability of inexpensive automobiles. The condition of this once-white granite structure, now sitting under a layer of soot from engine exhaust, provides further proof of the impact of the automobile.

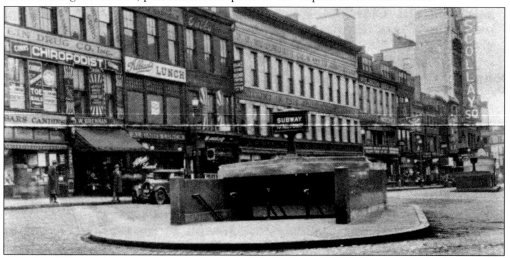

In conjunction with the 1926 street widening (to help alleviate the traffic congestion), Boston also decided to remove the original subway kiosks in both Scollay and Adams Squares, ostensibly because the imposing granite entrances presented a hazard by obstructing the line of sight for both drivers and pedestrians. This 1928 view toward Tremont Row shows the square now bereft of that wonderful kiosk.

Three
THE OLD HOWARD

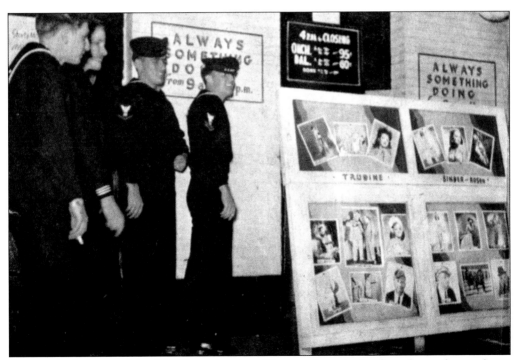

Seats in the balcony of the Old Howard, at just 60¢, are a bargain for these four sailors on leave in Boston in 1947. The sign on the wall promises "Always Something Doing," a phrase coined by Fred Doherty, a rumpled character of a man who was the theater's public relations and advertising manager from 1910 to 1940.

Some people called the Old Howard the "Temple of Burlesque." Ironically, the theater actually began as a church, built by the followers of Rev. William Miller, who had concluded, based on his mathematical calculations of the Bible's book of Revelation, that the End of Days would occur in 1844. When nothing happened, chagrined parishioners—who had given up all their possessions in preparation for the great event—rented out the tabernacle to Boyd and Beard, two theatrical producers. When the theater burned down after a special effect went awry during a January 6, 1846 performance of *The Piazzaro*, Boyd and Beard hired noted architect Isaiah Rogers to design this beautiful new theater in Quincy granite. The theater is shown here in the 1940s.

This advertisement promotes the first performance ever at the Howard, an English drawing-room comedy called *The Rivals*. Performances of music by Mozart, Verdi, and the ballet *Giselle* followed, to rave reviews and great box office sales. This success gave Boyd and Beard the confidence to rebuild the theater, which would become a Boston legend.

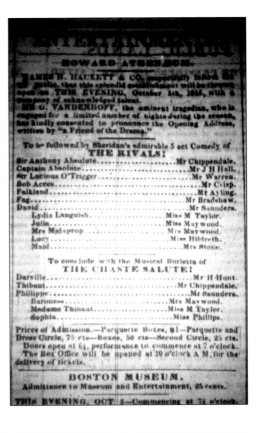

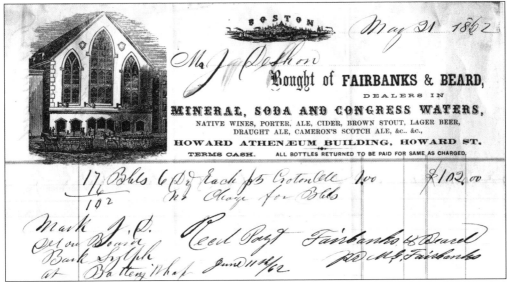

While the success of the Howard Athenaeum led the owners to create a new, modern facility that included amenities such as cushioned seats and a kerosene chandelier, the above receipt bears testimony to their lingering uncertainty about the theater's future. As a way to generate money, the owners built a brewery on the first floor, where they produced, bottled, and sold ale, porter, cider, wine, and beer. (Courtesy Boston Public Library.)

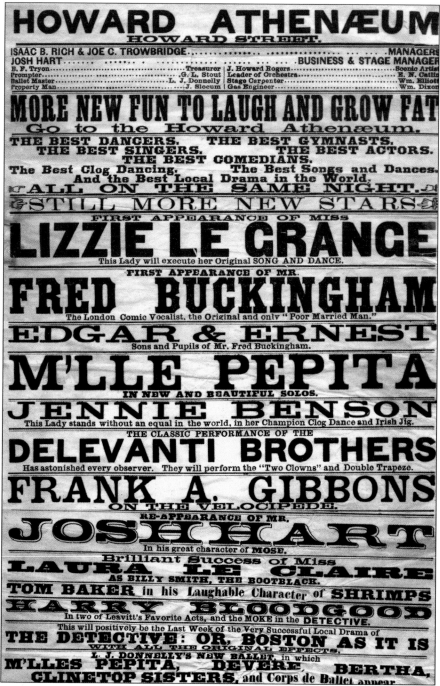

HOWARD ATHENÆUM
HOWARD STREET.

ISAAC B. RICH & JOE C. TROWBRIDGE...MANAGERS
JOSH HART...BUSINESS & STAGE MANAGER

B. F. Tryon..............Treasurer	J. Howard Rogers...............Scenic Artist	
Prompter..............G. L. Stout	Leader of Orchestra..............E. N. Catlin	
Ballet Master..............L. J. Donnelly	Stage Carpenter..............Wm. Elliott	
Property Man..............J. Slocum	Gas Engineer..............Wm. Dixon	

MORE NEW FUN TO LAUGH AND GROW FAT
Go to the Howard Athenæum.

**THE BEST DANCERS. THE BEST GYMNASTS.
THE BEST SINGERS. THE BEST ACTORS.
THE BEST COMEDIANS.
The Best Clog Dancing. The Best Songs and Dances.
And the Best Local Drama in the World,
ALL ON THE SAME NIGHT.**

STILL MORE NEW STARS
FIRST APPEARANCE OF MISS

LIZZIE LE GRANGE
This Lady will execute her Original SONG AND DANCE.

FIRST APPEARANCE OF MR.

FRED BUCKINGHAM
The London Comic Vocalist, the Original and only "Poor Married Man."

EDGAR & ERNEST
Sons and Pupils of Mr. Fred Buckingham.

M'LLE PEPITA
IN NEW AND BEAUTIFUL SOLOS.

JENNIE BENSON
This Lady stands without an equal in the world, in her Champion Clog Dance and Irish Jig.

THE CLASSIC PERFORMANCE OF THE

DELEVANTI BROTHERS
Has astonished every observer. They will perform the "Two Clowns" and Double Trapeze.

FRANK A. GIBBONS
ON THE VELOCIPEDE.

RE-APPEARANCE OF MR.

JOSH HART
In his great character of MOSE.

Brilliant Success of Miss

LAURA LE CLAIRE
AS BILLY SMITH, THE BOOTBLACK.

TOM BAKER in his Laughable Character of **SHRIMPS**

HARRY BLOODGOOD
In two of Leavitt's Favorite Acts, and the MOKE in the DETECTIVE.

This will positively be the Last Week of the Very Successful Local Drama of

THE DETECTIVE: OR, BOSTON AS IT IS
WITH ALL THE ORIGINAL EFFECTS,

L. J. DONNELLY'S NEW BALLET, in which

**M'LLES PEPITA, DEVERE, BERTHA,
CLINETOP SISTERS, and Corps de Ballet appear**

By the time of the Civil War, the Irish immigrants had changed the character of Scollay Square, literally driving the Brahmins away from the West End and lower Beacon Hill, and causing a precipitous drop in the Howard Athenaeum's box office receipts. Sarah Bernhardt may have been a fine actress, but she held little interest to the new citizens of Boston. So Josh Hart began booking acts that would attract customers. On this page is the upper half of a broadside (a posting outside the theater) for the week's performances in March 1869.

ENTIRE NEW OLIO OF FUN AND MIRTH.

Programme for the Week, commencing Monday, March 29th

OVERTURE..MR. CATLIN AND ORCHESTRA.

To commence with the very Laughable Act, by Leavitt, entitled

DIDN'T I MOVE HIM.

Fighting Joe...................Harry Bloodgood	Move Him....................Joe Buckley	
Mr. Haverdegrass...............A. J. Leavitt	Guardian of the Night.........Lew Donnelly	

DOUBLE ESSENCE .. **TOMMY AND CHARLEY**
ZINGARELLA MEDLEY ... MISS JULIA MELVILLE
CHARACTER AND COMIC SONGS MISS POLLY DALEY
Ixion Medley .. Lucy & Sallie Clinetop

Double Violin & Musical Entertainment by the Buckingham Brothers

HARRY BLOODGOOD IN HIS COMICALITIES

WALTZ ... M'LLE DEVERE

MISS JENNIE BENSON

In her UNEQUALLED CHAMPION CLOG DANCE.

A. J. Leavitt's Very Laughable Sketch, entitled

DR. CUREALL!

Dr. Cureall..........G. L. Stout	Tom Measles.......Joe Buckley	Old Gouty...........Tom Baker	
Jim Lehight..........A. J. Leavitt	Joe Ginger...Harry Bloodgood	Dinah Sten.........Lew Donnelly	

Invalids, &c., by the Company.

FRED BUCKINGHAM

IN HIS BUDGET OF FUN.

THE TWO CLOWNS!

BY THE DELEVANTI BROTHERS.

Miss LIZZIE LeGRANGE

In her Original Song and Dance, "I'M SO FOND OF DANCING."

L. J. Donnelly's Ballet Divertisement, entitled

LA ECHO TYROLEAN!

..Corps de Ballet

Introduction.......CLINETOPS, MELVILLE, WESTON, LE ROY & CORPS DE BALLET	
PAS STYRIEN.................LUCY AND SALLIE CLINETOP	
LA COQUETTE..................................M'LLE BERTHA	
GRAND PAS....................................M'LLE DEVERE	
LA ECHO......................................M'LLE PEPITA	
GRAND VARIATION...........................DEVERE AND BERTHA	
PAS DE DEUX..................................M'lle PEPITA	
GRAND CODA.......PEPITA, DEVERE, BERTHA, CLINETOPS, AND CORPS DE BALLET	
FINALE	

VOCAL & TERPSICHOREAN SPECIALTIES, EDGAR and ERNEST
STARLIGHT WALTZ................................M'LLE BERTHA

MISS JENNIE BENSON in her IRISH SONGS AND JIG

Startling and Wonderful Performance by the Star Gymnasts, on the Double Trapeze, by the

DELEVANTI BROS.

To conclude with John F. Poole's New Drama, (LAST WEEK,) entitled

THE DETECTIVE; OR BOSTON AS IT IS

With New Local Scenery by J. H. Rogers, and the following Cast:

MOSE, ONE OF THE B'HOYS.....................JOSH HART	
DICK FOSTER, THE DETECTIVE, (First Appearance).....W. H. THORNE	
BILLY SMITH, A BOOTBLACK.................MISS LAURA LE CLAIRE	
SAM, the Moke.............HARRY BLOODGOOD	LIZE, in love with Mose.....MISS JULIA MELVILLE
SIMON SPEARS, a Shrimp Pedlar.....TOM BAKER	LUCY ROBINSON.........MISS JULIA DAVENPORT
RALPH HUNTLEY, the Forger......G. L. STOUT	MISS STERNES..........MISS LUCY CLINETOP
ADAM RAYTON, his Friend........J. BUCKLEY	MOLLY MALONE, wid Cakes & Apples...MAST. TOMMY
MR. ROBINSON, a Merchant......A. J. LEAVITT	HARRY ALLEN, the boy that presents Checks,
GRADDLES, a Landlord...........J. SLOCUM	MISS SALLIE CLINETOP

CITIZENS, PEDLERS, SHOP GIRLS, &c.

Snow Storm. The Snow Balling. The Accident.

LOOK OUT FOR MORE NEW STARS. Look out for the New Military Drama

CARD TO THE PUBLIC.—We have in active preparation a New Sensation Drama of great interest. LOOK OUT FOR IT. IT WILL BE THE BEST YET.

On MONDAY NEXT, the great Irish Drama of the **GREEN BANNER, OR THE HARP OF ERIN.** JOSH HART in his Original Character.

LADIES' MATINEE - EVERY - SATURDAY, at 2 1-2 o'clk.
Doors open at 7 o'clock. Curtain will rise at 7 3-4 o'clock precisely.

Reduced Prices of Admission.

Dress Circle..................50 cts	Reserved Parquet and Orchestra.......75 cts		
Dress Box Chairs............50 cts	Private Boxes....................$3.00		
Family Circle................30 cts	Gallery.........................15 cts		

SEATS SECURED SIX DAYS IN ADVANCE WITHOUT EXTRA CHARGE. Box Office open from 9 A. M to 10 P.M.

A. M. LUNT, Steam Job Printer, 112 Washington Street, Boston.

Shown here is the lower half of the broadside for the Howard in 1869. In the early 19th century, Boston was a segregated city, and the upper balcony of the Howard was known as "nigger heaven" because it was where blacks were directed to sit. In 1853, when a free black woman named Sarah Remond showed up with a ticket to an orchestra seat she had purchased through the mail, management tried to put her up in the gallery. She refused and was forcibly ejected by police officers. Remond sued the theater for damages and, in a stunning moment for the nascent Civil Rights movement, she won a $500 judgment against the Howard.

This page, from a book on Boston theaters, shows the layout of the Howard Athenaeum. After the Civil War, with variety shows, olios, vaudeville, and burlesque, the theater became so beloved that it earned the nickname "Old Howard." A seat in the gallery cost just 15¢, meaning everyone could afford an evening there. (Courtesy Boston Public Library.)

Binder and Rosen were a comedy team that regularly played the Old Howard. According to Mike Munroe, a fellow performer, this publicity shot was of their signature routine, in which two men find a baby and comically attempt to locate the mother.

Funny man Artie Lloyd was one of hundreds who performed at the Old Howard. He was preceded by some of the greatest comedians and actors in vaudeville and burlesque—Maggie Cline, Gus Williams, Harrigan and Hart, Fanny Brice, Weber and Fields, the Marx Brothers, Bert Lahr, Joe Penner, Phil Silvers, Abbot and Costello, and Fred Allen, who called the Old Howard "the small-time actor's Broadway."

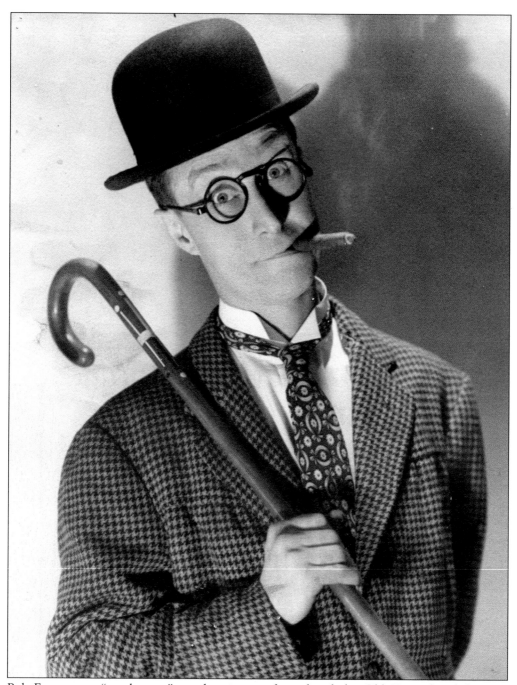

Bob Ferguson, a "top banana" on the circuit, often played the Old Howard. While some performers, such as Red Buttons, Milton Berle, and George Burns, would bust out of the circuit to become stars on radio, television, and the movies, Bob and others spent their entire professional lives in theaters like the Old Howard.

MISS ANN CORIO
Stageland's Most Beautiful Girl
OLD HOWARD THEATRE
Boston, Mass.

ALWAYS A GOOD SHOW

Old Howard Theatre Patron

Boston, Mass.

Imagine that as a young man you had attended an Old Howard performance during the late 1920s or early 1930s. You then received a letter from Ann Corio herself! This clever bit of promotion was just one of many concocted by public relations manager Fred Doherty.

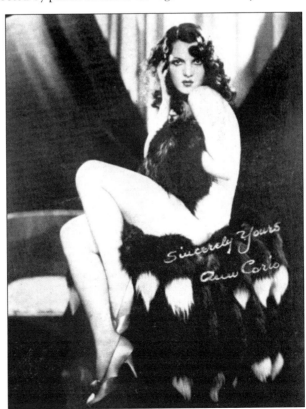

Now imagine you were a married man whose wife had opened the above letter, which also included this "autographed" picture of the Old Howard's star performer, Ann Corio.

Ann Corio, the undisputed star of the Old Howard in the 1930s, appears in her dressing room in 1936. In her autobiography, Ann wrote about her appeal among Harvard students, who flocked to the theater in such great numbers that some called it "Old Harvard." (Courtesy Boston Public Library; photograph by Leslie Jones.)

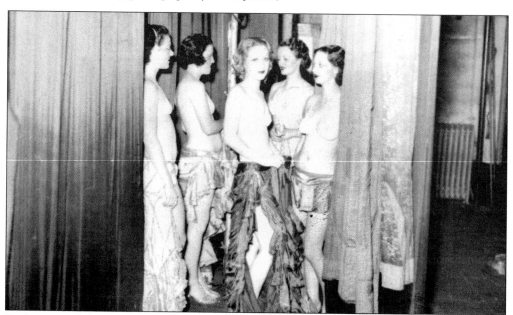

Backstage at the Old Howard, these chorus girls wait to perform in 1936. Since its incorporation in 1884, the Watch and Ward Society had been trying to shut down the theater for indecency. In 1930, the society convinced the Boston Board of Censors to close down the theater for one month because of indecency. (Courtesy Boston Public Library; photograph by Leslie Jones.)

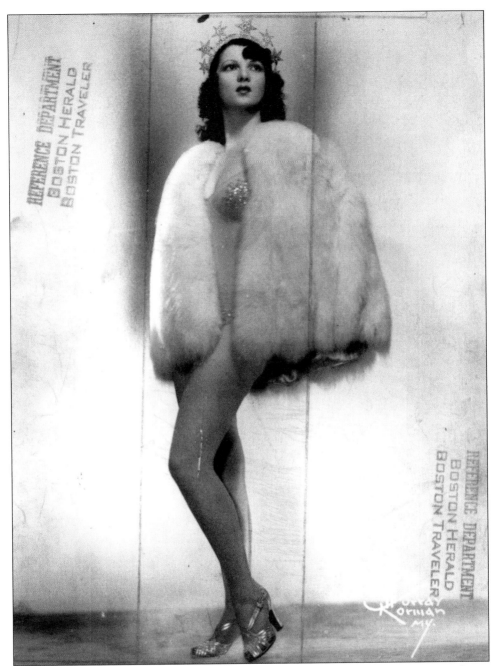

This Ann Corio publicity photograph was taken in the mid-1930s. Ann's book, *This Was Burlesque*, contains some wonderful anecdotes, including her story of the night she was invited to tea by a Professor Hooten of the Harvard Anthropology Department. "There I was having tea, if you please, with an academic great. . . . I asked him a question. 'Professor, how can you explain the great amount of deafness in Boston?' 'Deafness, I didn't know we had an excessive amount.' I said there must be, because night after night hundreds of people at the Old Howard asked for front-row seats. They claimed to be 'hard of hearing.'" (Courtesy Boston Public Library; photograph by Leslie Jones.)

Shown here is an entire program from the Old Howard *c.* 1940. Ann Corio told the story of a young Harvard undergraduate who had a crush on Peaches, a dancer of some beauty. "He used to send her flowers and candy," Ann said, "but his family found out and put an end to it." One wonders what sort of First Lady Peaches would have made had the young man, John F. Kennedy, been allowed to pursue his crush.

PROGRAM

Opening — Spring Time Jubilee Irving Karo, Asner & Ensemble
The Mary Club Sammy Smith, Bert Saunders, DeHaven, Karo
Swing Medley ... The Girls
Tie My Shoe Shorty, Stinkie & Company
The Brazillian Beauty Loretta Montez
Fountain of Love Letitia, Karo & Girls
The Vampires Bozo Snyder & Cast
That Flaming .. Vicki Welles
Talent on Parade Dallas Drake & Girls
The Court Room Shorty, Stinkie, Saunders, Karo & Cast
The Sheba of Shimmy .. Peaches
Ballet of Veils Letitia, Karo & Girls
Off Beat Rhythm ... Pepper Asner
True to Her Husband Shorty, Stinkie, Saunders, Montez, Welles
The Sophisticated ... Maxine DeShone
Finale — Easter Parade The Entire Jubilee
Goody Goody Sammy Smith, Dorothy DeHaven
Specialty World's Greatest Shot, Capt. Frank Gregory
Opening — Concert in the Park Karo, Asner & Ensemble
The Red Vest Shorty, Stinkie, Saunders, DeHaven, Montez
Sweet and Hot ... Vicki Welles
The Developer Bozo Snyder & Cast
That Bomb Shell ... Peaches
Modern Ballet Letitia, Drake & Ensemble
The Hollywood Beauty Maxine DeShone
Finale — Reprise of Hits The Company

—— ON THE SCREEN ——

"HOUND OF THE BASKERVILLES Basil Rathbone, Wendy Barrie
"FRONTIERSMAN" .. William Boyd

COMEDY — NEWS

● COMING ATTRACTIONS ●

MARGIE HART .. APRIL 15
BILLY AINSLEY .. APRIL 15
ZORITA .. APRIL 22
SUNYA (SMILES) SLANE ... APRIL 22
REGGIE WHITE ... APRIL 29
PAT ROONEY (The Old Timer himself in Person) APRIL 29
JERRY McCAULEY .. APRIL 29
MIKE SACKS .. APRIL 29

The Old Howard was the source of hundreds of great stories. On their Web site, family members of ophthalmologist and navy veteran Don Whitney posted a tale about how, during World War II, he and a group of his friends took a man named John—a devout Catholic intent on being a priest— to the Old Howard. Mortified, John demanded that the trip be kept secret, which of course compelled his friends to fabricate the following letter on Old Howard stationery: "Congratulations! You were the one millionth visitor to the Old Howard Theater on Saturday night. In recognition of this event, you are being awarded a pair of free tickets for another performance, and your picture will appear in the rotogravure section of this week's Sunday Herald." "John nearly had a heart attack," wrote Don. "Nearly a whole day went by before someone finally took pity and told him that the letter was a hoax. He didn't see the humor of the situation."

Ann Corio was already a 10-year veteran of the Old Howard when she headlined for the 1939 show advertised above. In 1929, she and manager Al Somerby noticed there were a large number of women attending her shows. (Ann, it should be noted, was always very proud of her act, maintaining that "I was never lewd or dirty. It was the sort of show husbands could take their wives.") So the theater began presenting a midnight "ladies only" show. The show's great success forced a major modification to the architecture of the 90-year-old theater: the addition of a ladies restroom.

62

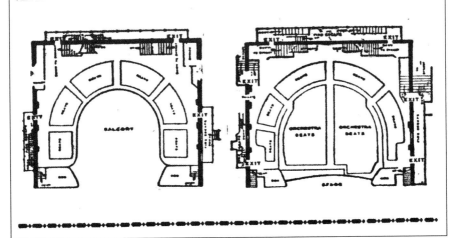

Shown here is the fourth and final page of the Old Howard program from the 1939–1940 season. As evidenced by the advertisement for the Niagara Shower Baths and Barbers, many apartments had no hot water or completely lacked running water. Places like the Niagara served a broad clientele of locals, as well as soldiers and sailors on leave.

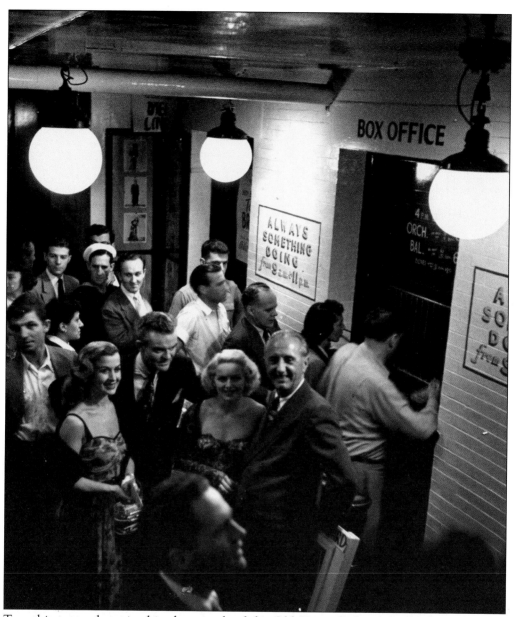

Two things stand out in this photograph of the Old Howard's box office, taken sometime around World War II (note the sailor in the back of the crowd). One is how many of these people are dressed up, with many of the men in ties and the women in elegant evening dresses, as if they were going to see a production of *Oklahoma* rather than Ann Corio. Also, the very fact that women are queuing up for a ticket also speaks volumes about the nature of the entertainment.

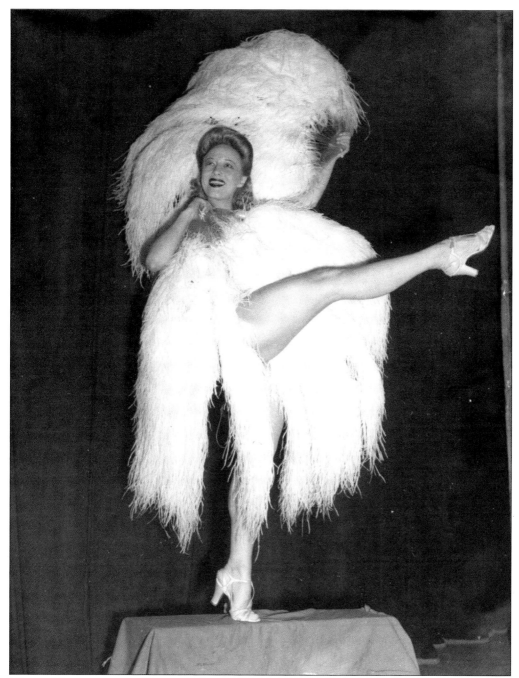

Elkton, Missouri, native Harriet Helen Gould Beck was better known to her legion of fans as Sally Rand. With a flesh-colored body stocking and two pink, seven-foot ostrich fans, Sally (who sometimes dabbled in bubbles) created an act that made her world famous. In 1933, at the height of the Great Depression, she was making $6,000 a week to perform at the Chicago World's Fair. Her shows at the Old Howard, while not as frequent as her fans would have liked, are remembered fondly by all. This photograph was taken in April 1935. (Courtesy Boston Public Library; photograph by Leslie Jones.)

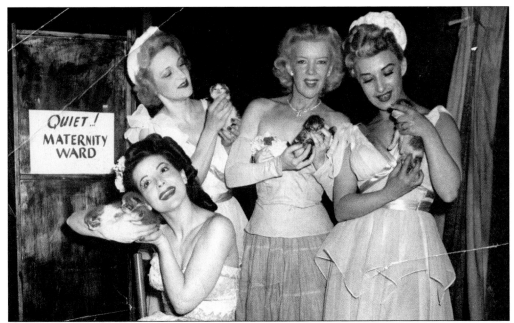

Mattie Mixon (center, standing) and two other chorus girls appear with Georgia Sothern (seated). Sothern, another Old Howard favorite, explained in her autobiography how "college boys [stood] in lines that stretched down the street and overflowed into Scollay Square. . . . It would take me an hour before I could get away in a cab and get to my hotel. I loved every minute of our stay at the Old Howard."

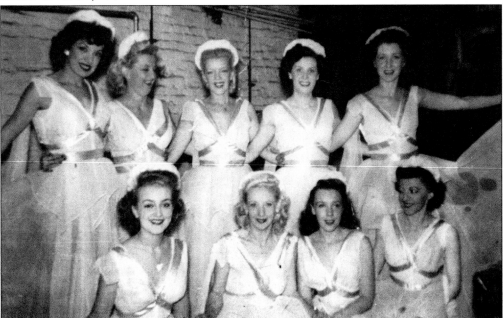

Pictured in this October 30, 1950 photograph taken backstage at the Old Howard are, from left to right, the following: (first row) Babs Johnson, Marge La Mont, Terry Mixon (Mattie's daughter), and Ruth Morgan; (second row) Lola Marsh, Loretta West, Mattie Mixon, Toney Loup, and Barbara Louden.

Chorus girls appear backstage. Terry Mixon believes that the woman seated is Barbara English, another local girl who "trod the boards" at the Old Howard. Terry recalled: "We liked the Howard because we had Sundays off and could spend time with family. Both my mother and I did scenes with the comics, and we did a dance act when needed."

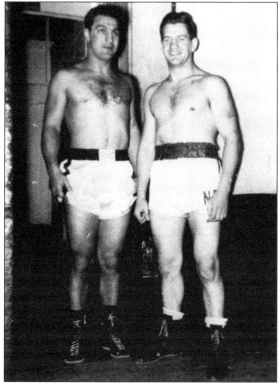

Manager Al Somerby hired Rocky Marciano (left) for a week's worth of shows at the Old Howard. According to James Calogero, who worked at the theater as a press agent, Marciano did three "shows" each day that week, consisting of his being interviewed on stage, then stepping into a ring for a three-round match with sparring partner Jimmie Sauer.

Bunny Weldon, choreographer at the Old Howard from the 1920s until it closed in 1953, works on a number backstage at the theater.

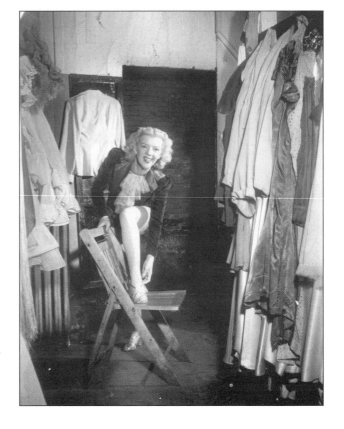

Mattie Mixon relaxes in the chorus girls' dressing room, backstage at the Old Howard in the 1940s. "It was not an easy job," recalled Mattie's daughter Terry. "We did three shows a day and four on Friday and Saturday. We had rehearsals on Tuesday, Wednesday and Thursday, and of course the midnight show on Friday, and the fourth show at 10 on Saturday."

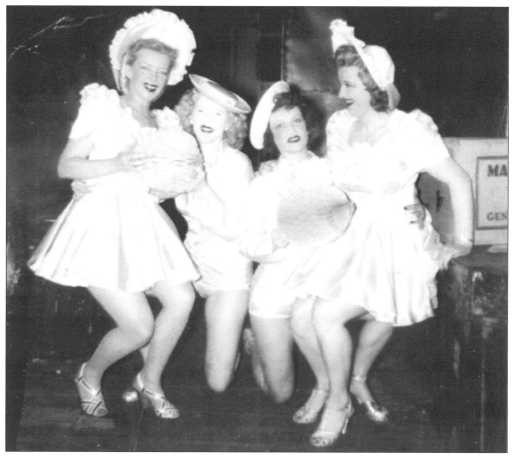

Pictured are, from left to right, Mattie Mixon, Pearl Johnson, Gladys ?, and Loretta West. "I worked with such comics as Al Rosen, Joey Cowan, Irving Benson, Bob Ferguson, and Mike Sachs," said Mattie's daughter Terry. "The theater would close for a few weeks each summer, and we usually went back to Florida then to visit with my Dad's family."

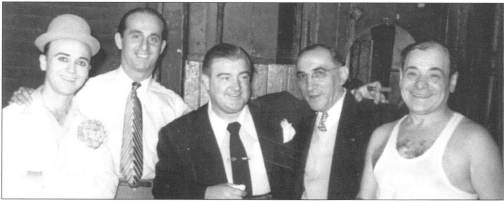

Comedians Bud Abbott and Lou Costello made an unannounced appearance at the Old Howard in 1946, performing their famous "Who's on First" routine. In this photograph are, from left to right, comic Jimmie Mathews, an unidentified employee, Lou Costello, stage manager Max Michaels, and comic Benny "Wop" Moore.

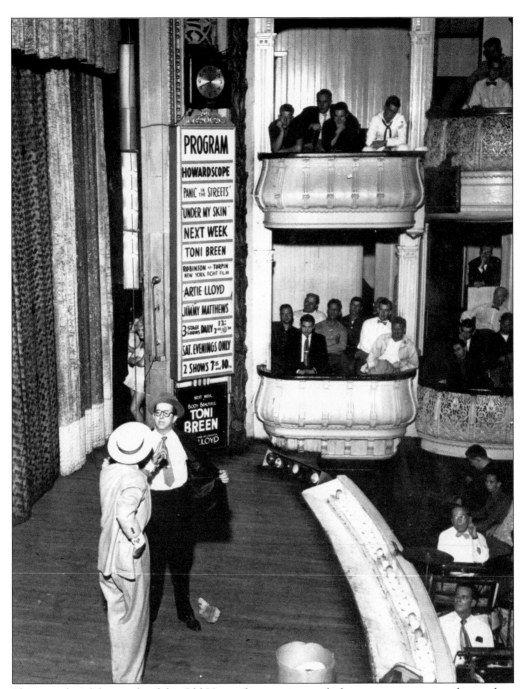

Photographs of the inside of the Old Howard are rare enough, but even more so are those taken during an actual performance. What sets this image above any ever seen is the legendary performer caught here in the middle of his act. Phil Silvers, who went on to great success on Broadway, television, and movies, was a performer on the burlesque circuit. In 1947, he came back to the Old Howard to perform a one-time show. Also evident here is that the Old Howard was a true family affair for Terry Mixon, who performed at the theater with her mother, Mattie. Playing the trumpet in the orchestra pit is her father. (Courtesy Terry Mixon.)

Four

OTHER SIGHTS
AND SOUNDS

On July 3, 1875, the telephone was born in this fifth-floor laboratory at 109 Court Street in Scollay Square. Before the building was demolished in the late 1920s, the lab was taken apart, piece by piece, with every item carefully numbered and preserved. The lab is now on display in the lobby of the New England Telephone Building in Post Office Square.

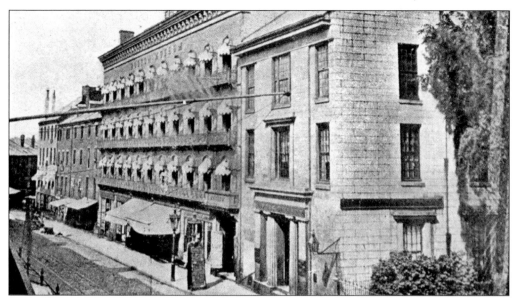

At the Museum and Gallery of Fine Arts, Moses Kimball displayed pieces of art, wax figures, animal specimens, and other items. In an ad-hoc theater there were a mix of olio acts—singers, musicians, trained canaries, and other early-vaudeville performers. The theater was so successful that, in 1843, 23-year-old Hammatt Billings was hired to construct a new building here on Tremont Street, just south of the Scollay Building.

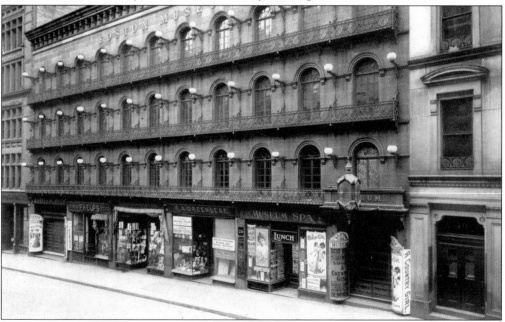

The Boston Museum is seen here on June 5, 1903. "The most popular form of entertainment in America in the nineteenth century," wrote theater expert James G. Mundie, "was far and away the dime museum. . . . Unlike the theaters and small circuses that had an unsavory reputation, the dime museum was presented as a safe and wholesome refuge, where upstanding citizens could learn of the newest scientific discoveries, or partake of the latest and best entertainments." (Courtesy Boston Public Library; photograph by N. L. Stebbins.)

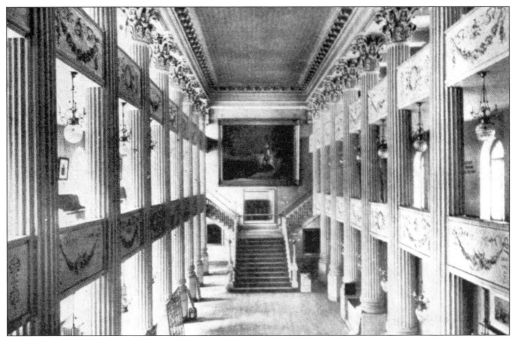

The Boston Museum (lobby shown here) included such displays as a "lifelike" wax re-creation of *The Last Supper* to a "Massacre by Pirates." Mundie wrote, "Here was a sort of nineteenth century one-stop-shopping: pantomime, minstrelsy, waxworks, song and dance, natural history, human oddities and more—all under one roof, and presented in such a way that the patrons felt they were bettering themselves through the experience."

This photograph of the green room at the Boston Museum was taken in the late 1800s. Legend has it that when theatrical lighting was in its early stages, lime was burned to create a very bright spotlight, hence the phrase "in the limelight." The light blinded the actors, causing them to see green spots in front of their eyes. They were led to the green room until their vision cleared.

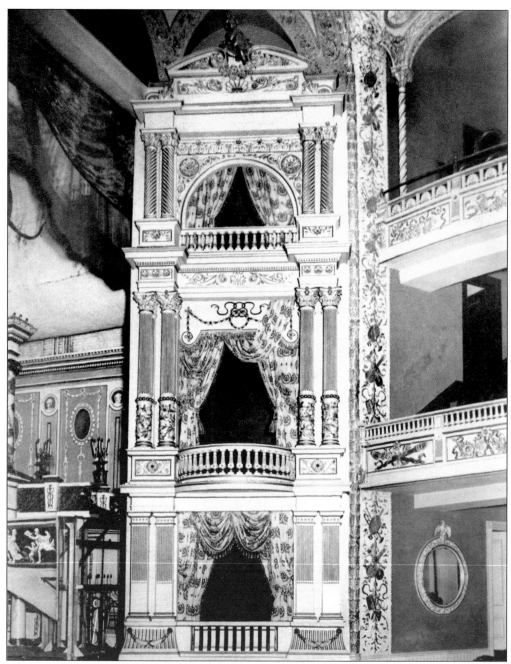

Along with the display space for hundreds of wax figures, mounted animals and birds, coin collections from around the world, and even an Egyptian mummy, the Boston Museum also contained a marvelously appointed theater. Before these ornate box seats and balconies came such renowned actors as William Warren, known to Bostonians as "The Prince of Comedians." He performed here for more than 40 years, often in the theater's popular staging of *Uncle Tom's Cabin*. The Boston Museum was also where Edwin Booth, the father of John Wilkes Booth, made his first appearance on any stage. This photograph was taken in the late 1800s. (Courtesy Boston Public Library.)

Seen here is the cover of the October 1898 program for the Boston Museum. James G. Mundie, on www.missioncreep.com writes, "Although the museums reached the height of their popularity in the late 1800s, dime museums would continue to function in one form or another through the 1940s."

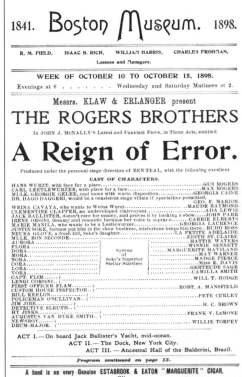

This page is from the Boston Museum's program for the week of October 10–15, 1898. As if the eclectic displays in the lobby or the entertainment in the theater were not enough, the Boston Museum also hosted a number of authors' readings. When Mark Twain appeared before an enthusiastic Boston crowd here, a contemporary described the "cataract of applause from the topmost rows of seats."

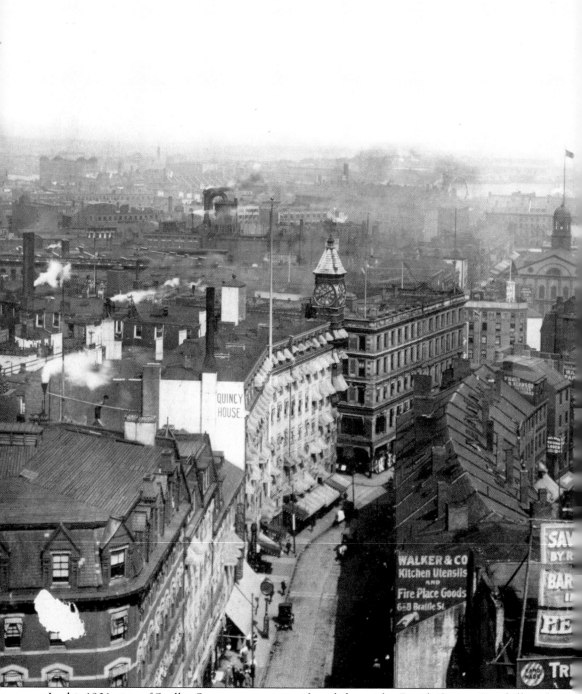

In this 1901 view of Scollay Square, one can see, from left to right, Brattle Street, Cornhill, and Court Street. Marston's Restaurant, which was discussed on page 24, stands on Brattle Street, between the Quincy and Crawford Houses. Frost and Adams, likewise shown on page 24, is visible on the left side of Cornhill. Advertisements for wallpaper, cigars, kitchen utensils, and other everyday items fill the view. On the top floor of the Sears Crescent Building (where today

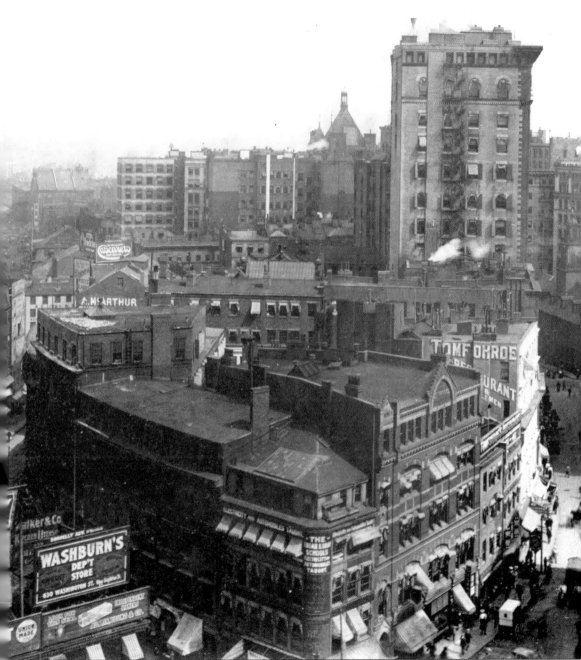

hangs the Steaming Kettle) is the Edgar S. Grady School, promoting "Electricity and Automobiles taught," while the *Herald* suggests that reading the paper will "Save Money." Beyond the Quincy House is evidence of a residence among all these businesses: someone has hung up his long johns to dry on a nearby roof. (Courtesy Boston Public Library.)

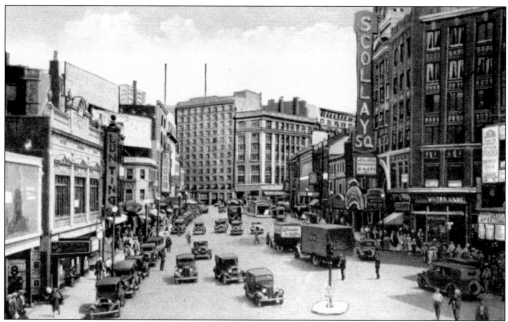

Looking southward from Bowdoin Square into Scollay, this picture was taken in the 1930s, after the removal of the subway kiosk. At the far end of the scene, along Court Street, are the Hemenway and United States Trust Buildings. Tremont Row, still thick with photography studios and theaters, lines the right side of the street. Despite the mounting Depression, Scollay Square continues to be a beehive of activity.

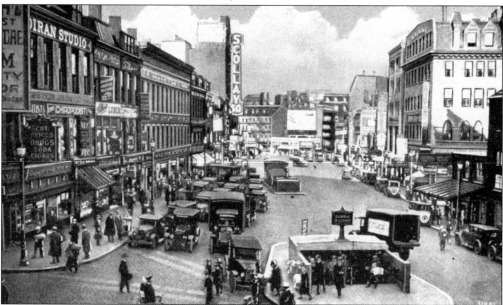

In this view, looking into Scollay Square toward the West End from the base of Pemberton Square, the subway kiosk has been removed. The effects of the street-widening project (which in the 1920s forced the "shaving" off of a couple dozen feet from the front of every building in the square) are striking, especially when contrasting the front façade of the Crawford House shown here with that pictured on pages 34 and 36.

Simpson's Loan Company was located at the head of Cornhill. The late City Councilor Fred Langone once stated, "Simpson's became known as one of the fanciest pawn shops in Boston, with all the Brahmins' fine jewelry." This actual receipt for a "hocked" piece of jewelry—a diamond necklace—comes from former performer Lilly Ann Rose, who says it "was a gift from a stage-door Johnny" to her mother, Margie LaMont.

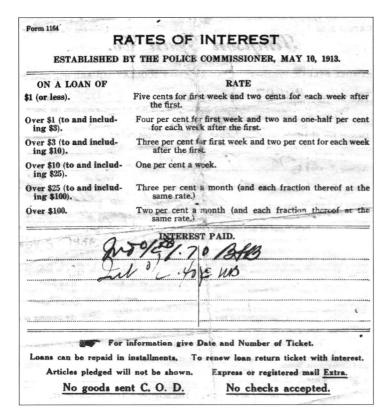

The back of the same receipt is shown here. Lilly Ann Rose explains: "In my book [*Banned in Boston*] I tell the story about the diamond pawned that Aunt Lillian loved, and her husband, Pat, bought the ticket from Margie, and got it out. My aunt wore that diamond until the day she died, and I still wear the diamond around my neck."

The Suffolk County Savings Bank was designed by Cass Gilbert, who also built New York's Custom House and Woolworth Building. According to a booklet published to celebrate the bank's 100th anniversary in 1933, "The architects' idea was an enlarged strong-box, its entrance flanked by four great Doric columns, . . . the classic Greek lines of the exterior symbolic of the inherent conservative policies upon which the bank was founded."

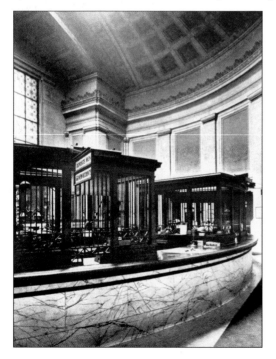

As explained in the Suffolk County Savings Bank's 100th-anniversary booklet: "The interior was designed to meet the requirements of modern banking. The banking room . . . typifies in a most happy manner the beauty that can be achieved when artistic is blended with the utilitarian. With walls of white marble, doors, windows and other metal work of bronze, and woodwork of fine rich-grained mahogany, the appointments . . . combine to reflect a dignified beauty."

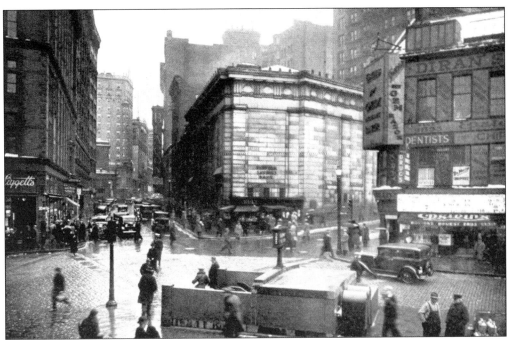

Looking over the subway entrance, down Tremont Street, on a rainy day in 1933, the Suffolk County Savings Bank dominates the corner of Court, Tremont, and Pemberton Square. At opposite corners of Scollay Square are the competing drugstores of Liggett's and Epstein's. This photograph was taken in 1933, at the height of the Great Depression.

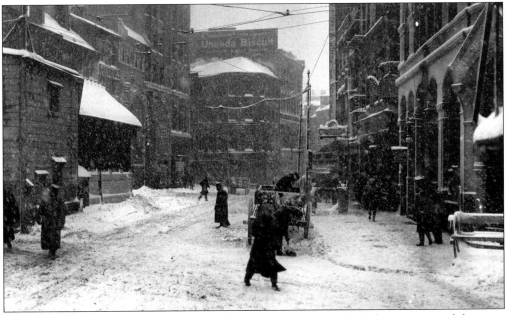

The Olympia and the Star, and even the Old Howard, were not likely doing very much business on this day in 1930. Photographer Leslie Jones captured the scene during a snowstorm that appears to have cleared the square of almost everyone but those tasked with removing the snow. (Courtesy Boston Public Library; photograph by Leslie Jones.)

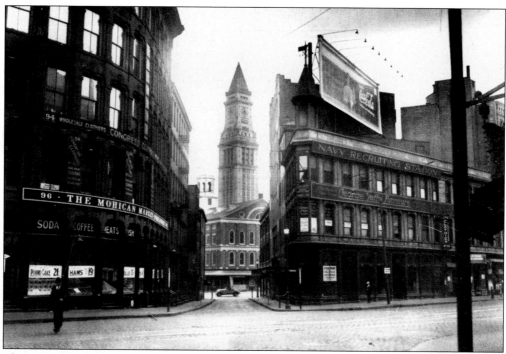

The corner of Washington and Elm Streets, near Adams Square, was photographed in 1930. The custom house tower, behind Faneuil Hall, is nicely framed between the buildings on either side of Elm Street. In the foreground, Washington Street, which is filled with wholesale dealers of clothing and furniture, crosses in front. Appropriately enough for the Scollay Square area, a navy recruiting station also is located here. (Courtesy Boston Public Library; photograph by Leslie Jones.)

John Moscaritolo grew up in the nearby West End, and was an amateur boxer who trained at Kelly and Hayes Gym, which was located right across the street from the American House on Hanover Street. John, who fought under the name "Kid Maski," was just 18 in 1939 when, like many proud pugilists, he had a photograph taken of himself at the gym.

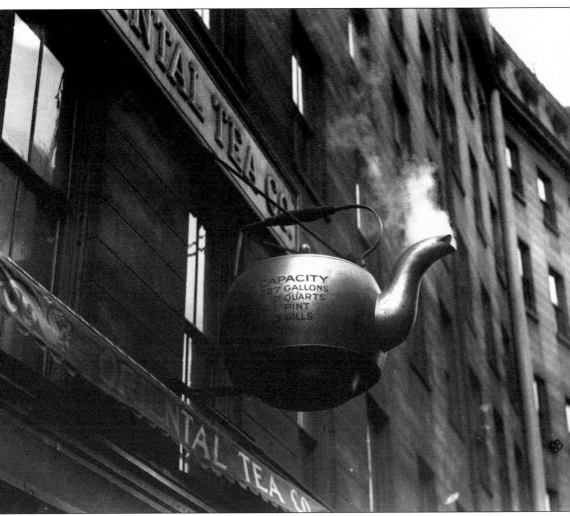

Save for Sally Keith's tassels and Joe and Nemo's hot dogs, few things from Scollay Square generate as much interest as the perpetually steaming kettle of tea (shown here on October 10, 1920) that was hung over the door of the Oriental Tea Company after the Civil War. On New Year's Day 1875, the question of just how much liquid the kettle could hold was settled in a public demonstration, which one paper estimated drew 12,000 people to the square. Perhaps it was the contest prize (a year's worth of free tea) that attracted such a crowd, but whatever the reason, the *Boston Post* reported, "By twelve o'clock the street was so thronged that it was with any difficulty that horse cars and teams made their way along." Eight people made the same guess and won the prize for coming closest to the kettle's actual capacity of 227 gallons, 2 quarts, 1 pint, and 3 gills. (Courtesy Boston Public Library; photograph by Leslie Jones.)

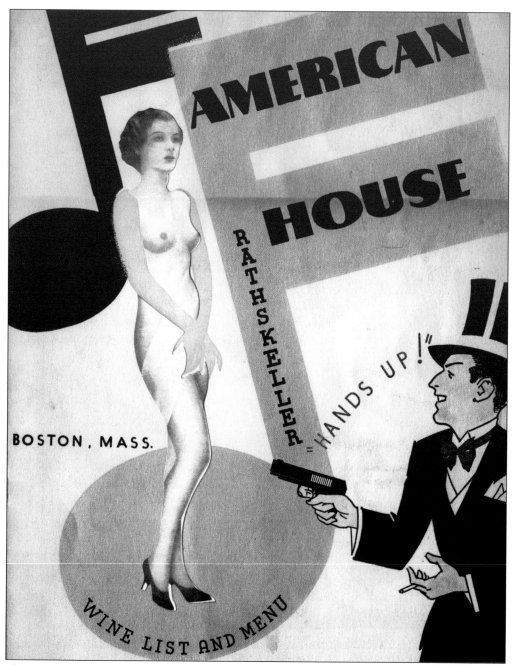

Shown here is the cover of the American House menu from the mid-1930s. Like the Crawford House, Young's Hotel, the Coolidge House in nearby Bowdoin Square, and many once-fine hotels from the 19th century, the American House boasted a fine dining room, but had to adapt to changing times and mores in Scollay Square in order to survive—many became speakeasies during the era of Prohibition.

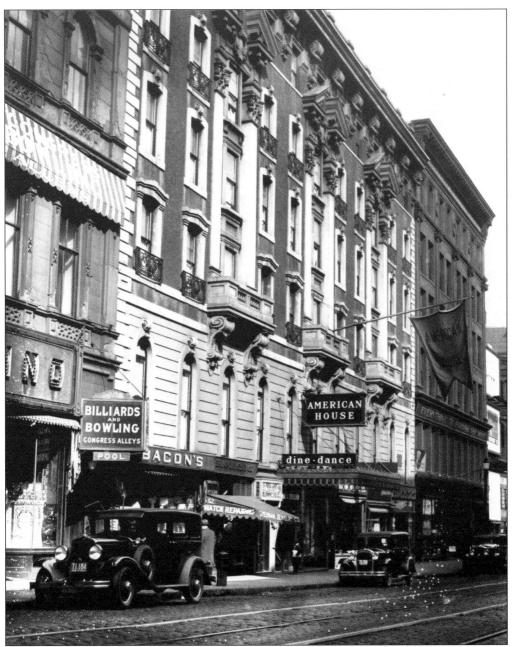

The American House is pictured here in the 1930s. One of this hotel's legacies was its role in a bit of chicanery by political bosses such as James Michael Curley. The voting laws at the time allowed a person to vote in a ward in which he resided, no matter how long. So when Curley wished to affect the outcome of an election in the West End, he would send members of his political machinery to register at hotels such as the American, the Quincy House, Young's Hotel, and others, thereby qualifying them to vote in that ward the next day. Since there were not enough rooms to accommodate the temporary residents, they brought their own mattresses and lined the hallways of the hotels. This practice earned them the nickname of "Mattress Voters." (Courtesy Boston Public Library; photograph by Leslie Jones.)

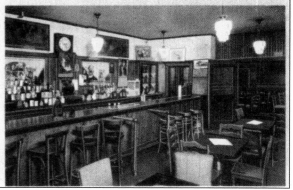

This postcard advertises the Imperial Hotel, located between Scollay and Bowdoin Squares. Despite what the card says, the atmosphere was anything but "homey." The author's first Scollay Square story came from his uncle Alphonse Abbatello, a doctor on a destroyer during World War II. Because of all the sailors who got into fights at places like the Imperial, the doctor had to spend his shore leave in the infirmary tending to their wounds.

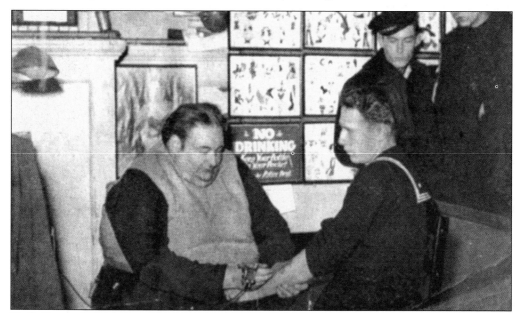

Ted's Tattoo Parlor was situated just above The Tasty restaurant, at the intersection of Hanover Street and Scollay Square. While his buddies look on, a sailor engages in the long-practiced tradition of sailors on shore leave. This lucky boy is receiving his tattoo from Ted himself. (How the young man felt about the permanent artwork the next morning was not recorded.)

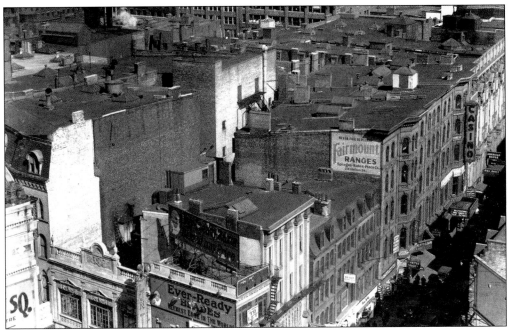

This northeastward view was photographed from behind Tremont Row in the 1930s. On Hanover Street is the Casino Theater, where the marquee advertises "Billy Watson's Burlesquers." Watson was a local favorite, whose nickname was "Sliding Billy Watson," thanks to a routine in which he slipped across stage on a banana peel. Next door to the Casino, the American House marquee announces "Dime a dance." (Courtesy Boston Public Library; photograph by Leslie Jones.)

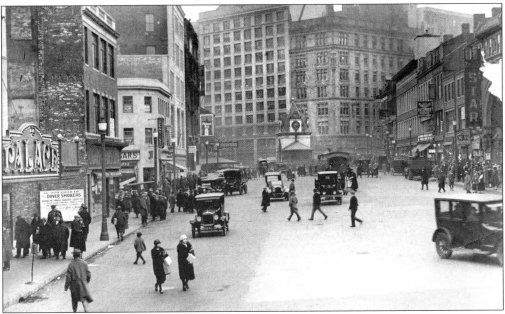

Christmas was just two days away when this photograph was taken in 1925. Prohibition, the federal amendment passed in 1919 that banned the sale of alcohol, may have been in effect, but that did not stop a number of "entrepreneurs" in Scollay Square from satisfying the demands of a thirsty public. (Courtesy Bostonian Society–Old State House.)

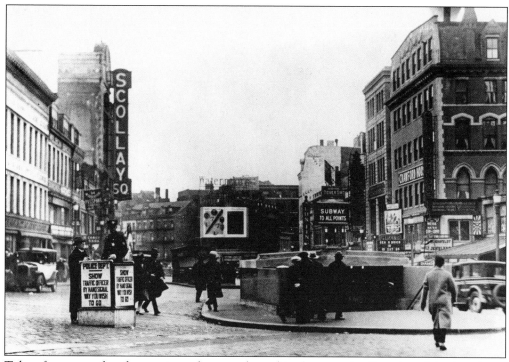

Taken five years after the previous photograph, and in the opposite direction, this view shows Tremont Row on the left and the Crawford House on the right. The kiosk was removed to help improve traffic flow, but a policeman was still stationed at the crosswalk to help subway riders make it safely to the island where the entrance was located. (Courtesy Bostonian Society–Old State House.)

This wonderful photograph, taken in 1925 from the third floor of Barristers Hall in Pemberton Square, displays Scollay Square during the height of the Roaring Twenties. Still roaring is the competition between Epstein's and Liggett's Drug Stores, which frame this view down Court Street. The Old State House sits nestled among the office buildings (such as the Ames Building). (Courtesy Bostonian Society–Old State House.)

Five

SALLY KEITH AND THE CRAWFORD HOUSE

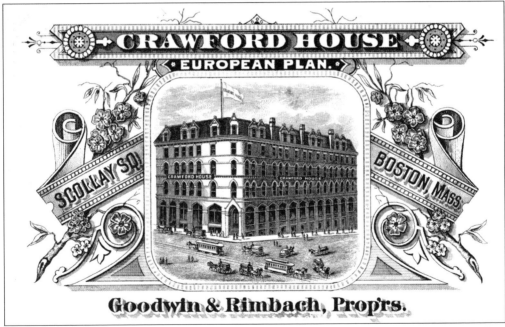

This promotional card for the Crawford House dates to *c.* 1890, soon after the original hotel on Brattle Street was replaced by a Gothic annex on Court Street. Inside the Crawford House at this time was Stumpke and Goodwin's Restaurant, which, according to *King's*, "comprises two large and beautiful rooms—one on each of the two floors. The lower room is for gentlemen and the upper one for ladies."

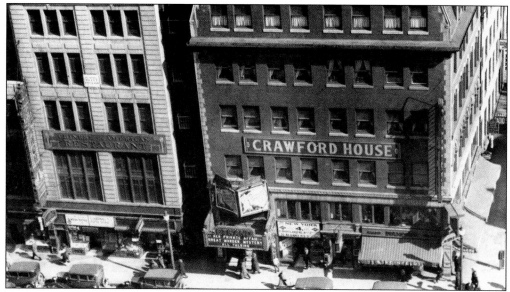

In this photograph of the Crawford House, taken on February 27, 1930, motion pictures with sound are still something of a novelty, as the marquee to the Strand Theater announces that *Her Private Affair* is "All Talking." Scollay Square is still a transportation center; visible are two bus ticket offices on this one block. The bank that stood at the corner of the Crawford House has been replaced by Scheinfeldt's Jewelers. (Courtesy Boston Public Library; photograph by Leslie Jones.)

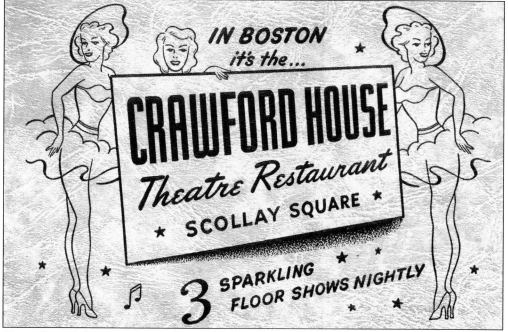

Shown here is the souvenir cover for photographs taken at the Theatrical Bar in the Crawford House. At the Theatrical Bar, one could see performers—and future television stars—such as Frank Fontaine (*The Jackie Gleason Show*), Larry Storch (*F Troop*), Alan King, Don Rickles, and Jack Soo (*Barney Miller*), among others, honing their comedic skills.

90

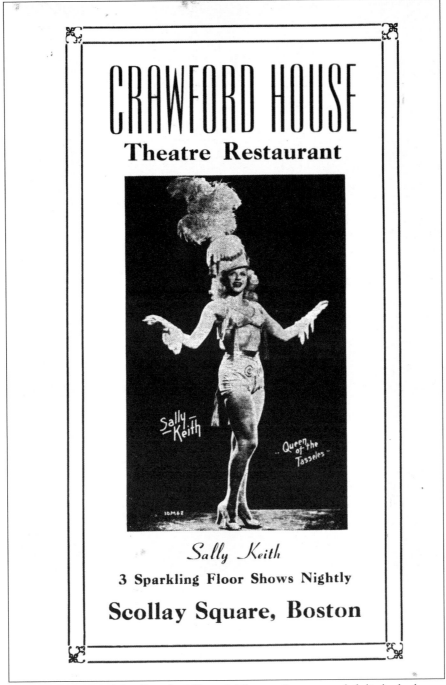

The cover to the menu of the Crawford House's Theater Restaurant left little doubt as to who was the star attraction. The author's favorite Sally Keith story is the following: In 1943, a teacher told his medical students to meet him that night at the Theatrical Bar for a Sally Keith show. (All the students in the class were men.) "The next day," a student recalled, "our professor gave us a pop quiz with only one question: name the muscles Sally Keith used in her act last night. Nobody passed the quiz!"

91

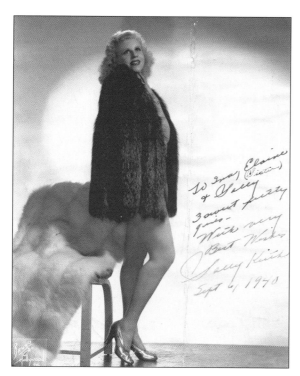

Susan Weis, Sally's niece, has some very personal memories of the woman whose career brought her from Chicago to Boston and made her a star. She talks of her aunt's siblings: "Sally's brothers were quite varied in their occupations. There was an orthodox rabbi, a cantor, an electrician, a fireman (later turned policeman), two used-car salesmen, a mechanic, and a restaurant manager." To clear up one legend: Sally's dad was not a policeman; he was a house painter.

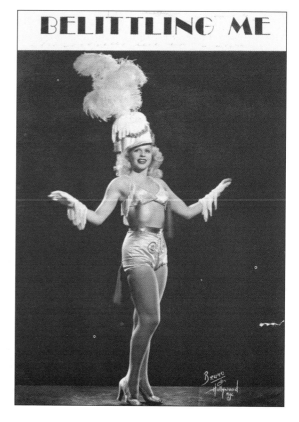

This is the cover to the sheet music for the one song written by Sally Keith. The lyrics are as follows: "Belittling me, won't alter my love for you. Belittling me, will get you nowhere, if making a fool of me makes you feel grand, Then darling I'll be the fool, you see I'm yours to command. Belittling me, won't shatter my dream for two. It's easy to see, you're not playing fair. Remember the tables turn on people like you, before it's too late to learn, stop belittling me."

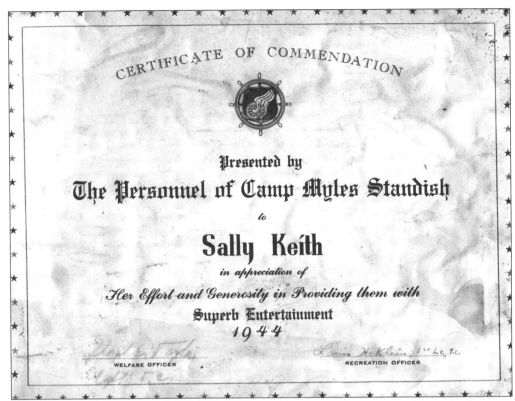

CERTIFICATE OF COMMENDATION

Presented by

The Personnel of Camp Myles Standish

to

Sally Keith

in appreciation of

Her Effort and Generosity in Providing them with

Superb Entertainment

1944

WELFARE OFFICER RECREATION OFFICER

Also well documented was Sally's support of the soldiers and sailors of World War II. She was a popular and frequent participant in USO shows. This certificate, from Sally's personal scrapbook, was presented to her by the grateful boys of Camp Miles Standish after a performance in 1944.

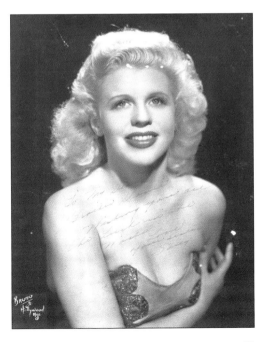

Sally Keith autographed this publicity photograph. "My family owned the Crawford House," recalls Elaine Kantor Whitener. "My sister, my mother, and I . . . would have to work as cashiers at the various bars in the Crawford House on weekends and/or holidays, especially during the war when the place was so crowded. Sally Keith was real close to our family and came to our house for dinner a lot."

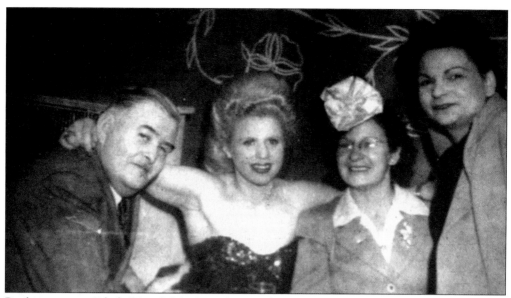

Booking agent Ethel "Ettie" MacKay (pictured second from right, with Sally and two unidentified patrons) remembers Sally's purchase of a gold convertible Cadillac, which Ettie drove because the tassel queen "was so bad behind the wheel. But we were two blonds in a gold Cadillac. What a sight we must have made!" Elaine Kantor adds, "Sally's favorite saying was, 'If I could only learn to drive as well as I can handle my tassels.'"

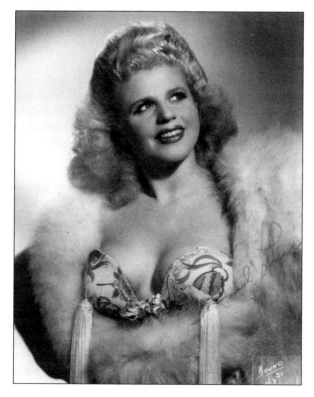

Sally's niece Susan Weis writes: "Prior to moving to New York and marrying Arthur Brandt, Sally lived in Hollywood, Florida. Our family would go every Christmas. Sally decided to cook a dinner for all of us. . . . It was a memorable disaster. . . . Her intentions were good, but she was no cook! It was on that trip that her nasty little Chihuahua bit me. She took that mean-tempered little creature everywhere with her."

From Elaine Kantor comes this wartime Christmas card that Sally sent to family, friends and associates. Sally made quite an impact on the thousands of young boys who swarmed into Scollay Square, so much so that Ed McMahon, Johnny Carson's sidekick on *The Tonight Show*, mentioned Sally's passing when she died in 1967.

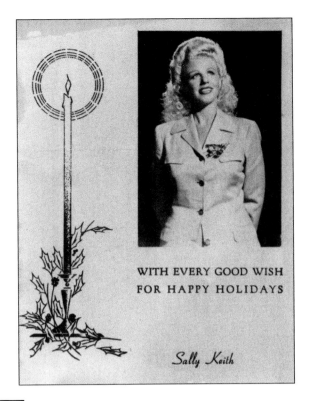

WITH EVERY GOOD WISH
FOR HAPPY HOLIDAYS

Sally Keith

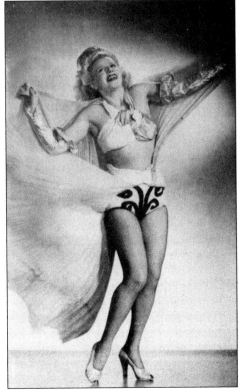

Sally Keith protégée Lilly Ann Rose recalled, "Sally was paranoid about losing her furs and her jewelry." This fear was well-founded; on at least one occasion while staying at the Crawford House, Sally was beaten and robbed of jewelry and money. And to show how big a star Sally was at the time, the January 5, 1948 attack was front-page news in several daily papers.

Here, Lilly Ann Rose emulates her own favorite performer, Ann Corio. "I was still in school but soon would be out for the summer and applied at the Casino, thinking my mother, who was at the Howard, would not find out. But I did work the Casino, the Crawford House, Jack's Lighthouse, and other clubs in Boston. Terry and Mattie Mixon worked with my mother, Marge LaMont, at the Old Howard."

A way for female performers to make a few extra dollars was to pose for photographs with visitors to the Crawford House. The pictures would go inside the cover shown on page 90. Here Lilly Ann Rose, at age 16, poses with a young serviceman, who appears to be quite happy. Why the unidentified man did not take his photograph with him remains a mystery.

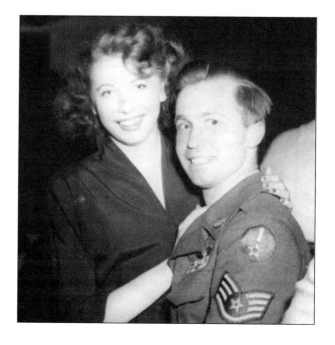

Six

THE LAST DAYS OF
SCOLLAY SQUARE

A beat cop speaks with a pedestrian in this 1957 view from the subway entrance down Cornhill. Between the Cornhill entrance to the Court Street Tavern and Colesworthy's Book Store, we can see that the Phoenix Coffee Mills, the business advertised on the turn-of-the-century postcard on page 27, is still operating. (Courtesy Bostonian Society–Old State House.)

Joe Merlino and Anthony Callogero owned a barbershop on Stoddard Street, widely claimed to be "the shortest street in Boston," which ran from Cambridge Street to Howard Street. One cold winter's day in 1909, they let a friend inside the shop to sell his hot dogs. When he left town, the men (who would soon marry each other's sisters, thus making them brothers-in-law) continued selling the hot dogs, so many that they abandoned their prior endeavor and opened a full-fledged restaurant. The proximity of the Old Howard (across the street) and the rest of Scollay Square helped make Joe and Nemo one of the most popular places to eat in Boston. The Old Howard connection cannot be overstated. When the city closed down the theater in 1953, revenues in the restaurant dropped by $500 a day! (Courtesy Boston Public Library; photograph by Leslie Jones.)

Scollay Square had but five years left when this photograph was taken from Sudbury Street on May 22, 1957. Here the wonderful lighthouse marquee of Jack's Lighthouse is now pitted, worn, and badly in need of a paint job. It would not get it. With suburban flight in full swing, the area was already becoming depressed when the city began touting plans for redevelopment in the late 1950s.

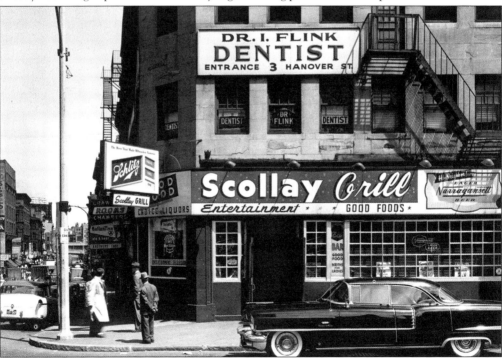

Dr. William Thomas Morton would be pleased. It is 1955, and though Scollay Square is in decline, it still boasts its share of dentists, like Dr. Flink. He practiced at 39 Scollay Square, just above the Scollay Grille, which, in this image, promotes both Narragansett Beer and "Booths for Ladies." The new elevated Central Artery is visible farther down Hanover Street, on the left. (Courtesy Bostonian Society–Old State House.)

The brand-new Central Artery, which destroyed large portions of the North End, the downtown business district, and Chinatown, cuts across the upper right corner of this 1959 aerial shot. The New England Telephone Building in Bowdoin Square and the 1939 courthouse in Pemberton Square stand at the top of this view, while the Park Street Church is at the lower left. The tangled mass of streets and alleys making up Scollay Square lies east

of Pemberton Square. The scene farther down Brattle and Hanover Streets provides evidence that many building owners, finding it too difficult to rent out their office space, have torn down the structures and opened parking lots. Unlike today, when historical preservation laws and public funds help property owners renovate their old buildings, few people questioned the destruction of these historic blocks at the time.

In preparing the residents and businesses for the coming construction, the Boston Redevelopment Authority took a number of survey photographs in the late 1950s, such as this image of the corner of Elm and Brattle Square, which is close to the site of the Brattle Square Church. Down Elm Street and across Washington Street to Dock Square is Faneuil Hall.

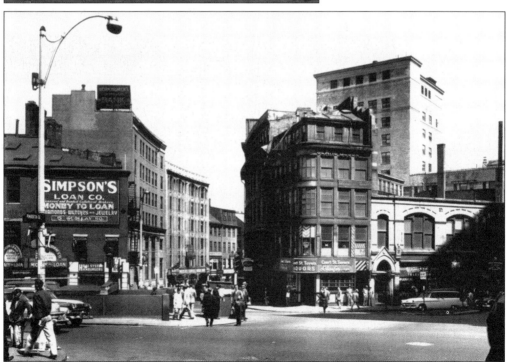

Simpson's Loan Company and the Court Street Tavern frame the head of Cornhill in this eastward view, photographed from the entrance of Pemberton Square in 1957.

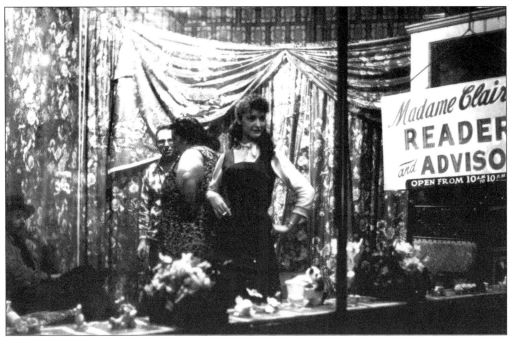

Photographer David Lawlor now resides in Big Sky country, but in the 1950s, he said he "went into Boston and took pictures in Scollay Square. . . . The picture of Madame Claire was taken on Howard Street, a few doors toward Scollay Square from the Old Howard. . . . The young assistant of Madame Claire was very inviting to have us come in to enrich our knowledge, and was amused at our picture taking."

About this photograph, David Lawlor wrote: "The picture of the entrance to the Casino theater shows three men on the path that I and many others have followed to enjoy the offerings and presentations of the management of the Casino Burlesque Theater. To be charmed and titillated by the dancers, amused by the comics, and only taken in once by the Candy Butchers."

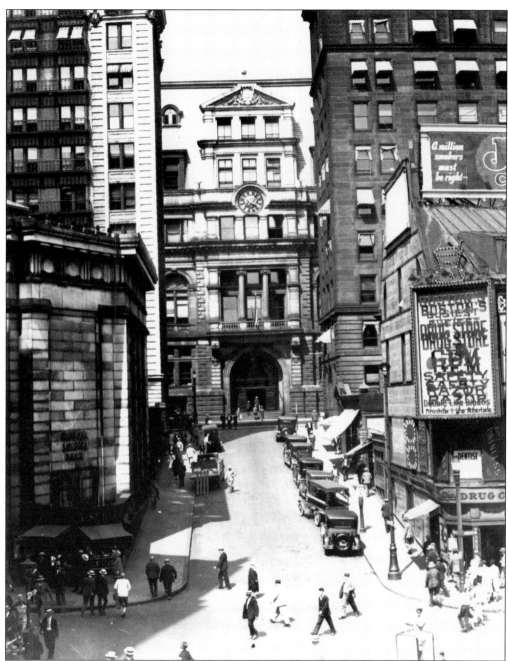

Standing at the base of Pemberton Square, Epstein's Drug Store ("Boston's busiest," according to the sign over the front door) was a Scollay Square landmark. Just across the street, one can see a corner of the Suffolk County Savings Bank in this late-1920s photograph. At the top of the street is the front door to the Pemberton Square Courthouse. Sweeping across this entire view today is building Three of 1-2-3 Center Plaza. Thanks to an agreement hammered out between judges, lawyers, developer Norm Leventhal, and the Beacon Construction Company, an escalator located in the lobby of Three Center Plaza is supposed be kept in working order "in perpetuity."

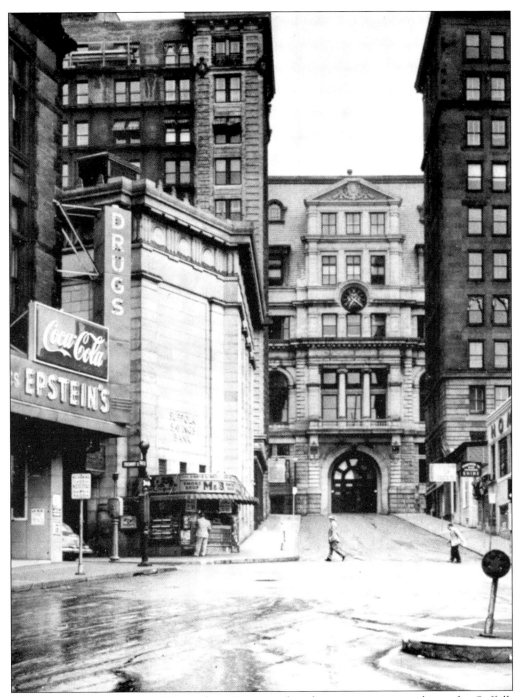

This photograph from the 1950s, taken 30 years after the previous image, shows the Suffolk County Savings Bank is still in its place on the south side of Pemberton Square. But across the street, an original part of Tremont Row has been replaced with a low-rise office building. The new construction forced Epstein's Drug Store to move diagonally across the street to the corner of Tremont and Court, ironically to the same storefront that had been occupied for many years by a branch of the competing drugstore chain, Liggett's.

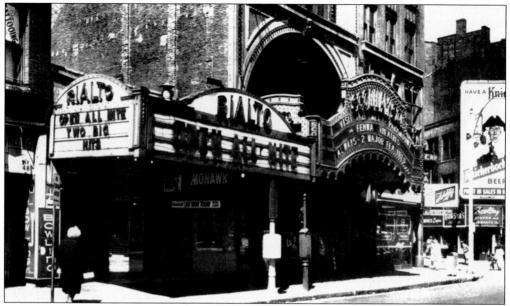

Live stage shows, vaudeville, and burlesque are faded memories at both the Scollay Square Theater and the Rialto (formerly known as the Star Theater). Though both are operating here in the late 1950s, neither is even bothering to promote its movie feature. (The Scollay Square Theater is even using its marquee to promote another theater located in the Fenway.) Clearly, the owners of these theaters knew that Scollay Square's time was running out.

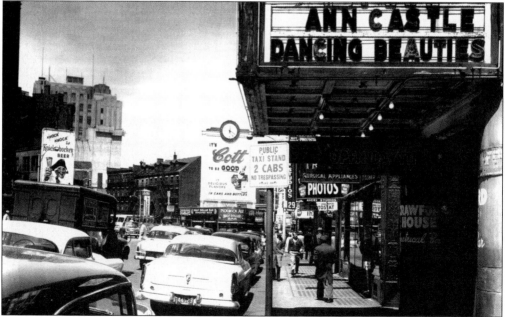

This view looks northward from the corner of Brattle Street toward the Half Dollar Bar (near Sudbury Street) in the 1950s. The New England Telephone Building dominates Bowdoin Square in the distance. Directly in front is the marquee for the Theatrical Bar at the Crawford House, and farther down the street is the Avery Photo Studios, another business owned by Julius Epstein of Epstein's Drug Store.

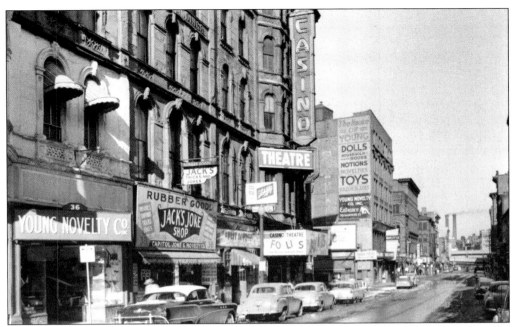

This view northward across Hanover Street on February 5, 1956, was photographed when the Casino Theater was the only "burly" left in Scollay Square. The Old Howard had been shut down by the city in 1953. The new, elevated Central Artery (since replaced by a tunnel) is visible down the street. (It cut Hanover in two when it was erected in 1952.) At 38 Hanover Street is Jack's Joke Shop, the nation's first such establishment.

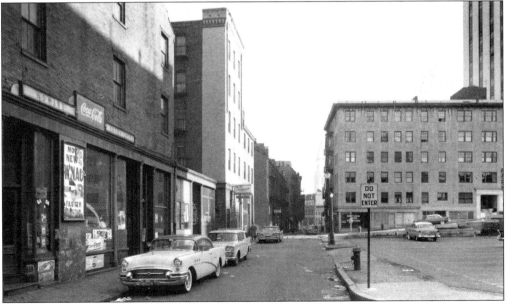

This photograph taken by the Boston Redevelopment Authority in May 1961 shows the view down Howard Street, in the direction of the Old Howard. It is hard to tell if the Howard Coffee Shop is even open. Down the block are several bars and a rent-by-the-hour hotel. The 1939 courthouse hugs the right side of the image, and the custom house peeks out behind the building at the end of the block.

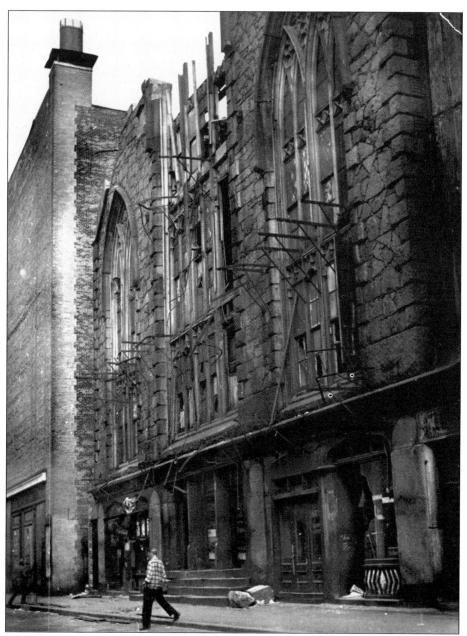

Ann Corio, in *This Was Burlesque,* tells what happened to the Old Howard, which was shut down by the city in 1953. Seeing box office receipts tumble after World War II, the owners abandoned the theater. "In 1959 the Howard National Theatre and Museum Committee was organized to save the theatre from threatened demolition. The committee wanted to convert the Old Howard into a national shrine, where operas and plays could be presented. . . . In 1961 . . . a mysterious fire started in the theatre and swept through the whole interior. Only the charred outside shell remained standing." The fire department's official report stated, "This fire is of undetermined origin," but skeptical committee members, who experienced tremendous resistance from officials in their plan for the theater's restoration, point to the quickness with which the city moved in several cranes to finish the job.

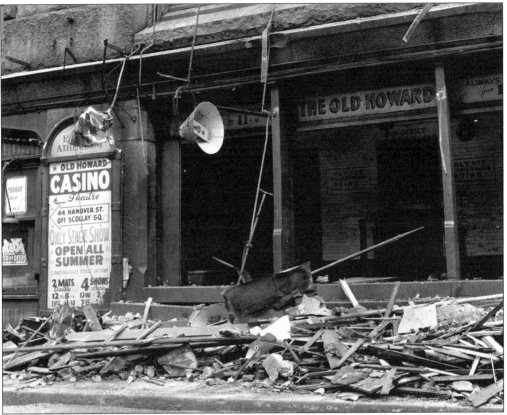

The owners of the Howard also owned the Casino Theater on Hanover Street, which they renamed the Old Howard Casino to capitalize on the legendary theater's reputation. This name change has also caused many to think that they had been to the Old Howard when, if their sojourn was between 1953 and 1961, it really was the Casino they visited. (Courtesy Bostonian Society–Old State House.)

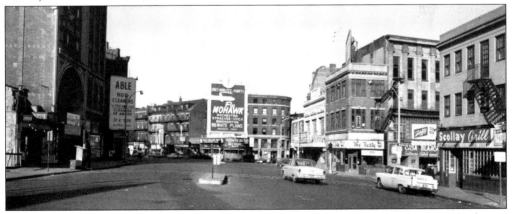

The last days of Scollay Square are vividly captured in this Boston Redevelopment Authority photograph from 1962. On the left, where construction of 1-2-3 Center Plaza would soon begin, the Rialto Theater has already been razed, while Scollay's Olympia has been turned into a store. A sweep around the square shows that most of the businesses that remain open are bars, including the Half Dollar Bar, Casa Blanca, and the Scollay Grill.

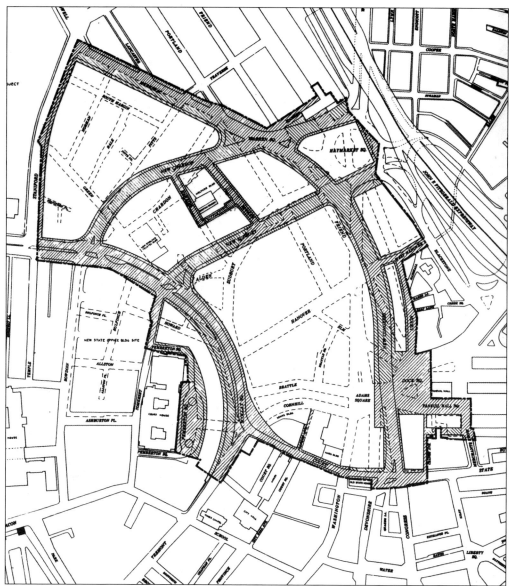

The Boston Redevelopment Authority's Right of Way Adjustment Plan, published on July 3, 1962, shows the streets of Scollay Square as dotted lines, and the new streets and avenues that would replace them in gray. More than 20 streets would be replaced or realigned as six broad avenues. The streets in the center area would be replaced by city hall on the east, and by the John F. Kennedy Federal Building on the north, with the rest to be bricked over as a public plaza. Only the Sears Crescent and Ames Building would remain, on the southern side.

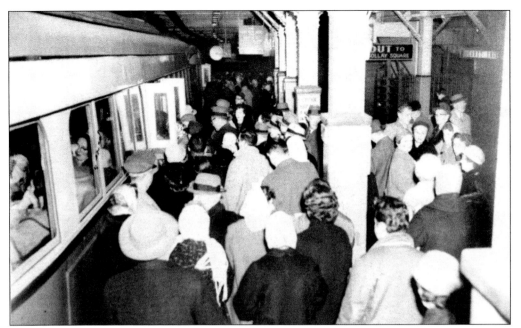

Looking southward on the southbound platform of the Scollay Square station, this view highlights the evening rush hour of February 3, 1959. The station would become world renowned that same year, when the Kingston Trio would record the campaign song for mayoral candidate Walter O'Brien, who had made a recent nickel-fare increase the cornerstone of his failed 1949 campaign. The song would reach No. 15 on the Billboard Top 40 chart.

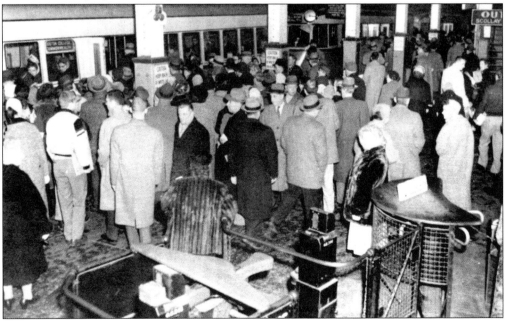

This photograph was taken on February 9, 1959, looking northward on the southbound platform. Lyrics from the Kingston Trio hit, "The MTA Song," include, "Charlie's wife goes down to the Scollay Square station every day at a quarter past two, and through the open window she hands Charlie a sandwich as the train goes rumblin' through."

The Charlestown Savings Bank's Washington Street branch in Adams Square, pictured here in 1961, would soon close to make way for the construction of the new city hall. This scene includes a rotary telephone and a mechanical adding machine, remnants of a bygone era.

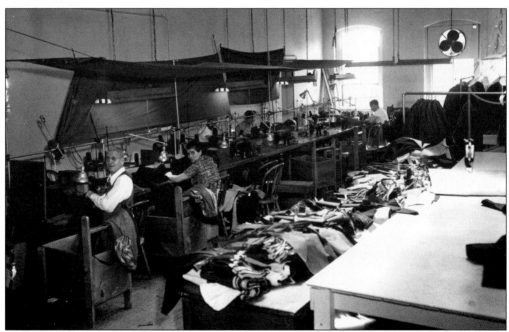

The Albert Specialty Shop was located at 132 Hanover Street. In *Always Something Doing,* it was explained that "despite the discouraging economic numbers, . . . there were still 900 businesses that employed more than 5,000 people in the 50-acre site scheduled for demolition." The move by some businesses to relocate outside the city was a financial disaster for many workers, who could not reach their employers' new locations.

After the Civil War, William Lloyd Garrison and his fellow abolitionists left Cornhill, and the street developed into the center of the used-book and magazine trade. John F. Kennedy was among the thousands of college students who, along with researchers and book lovers (like the woman browsing a bargain bin, at right), flocked to shops such as the famous Brattle Book Store. (Courtesy Boston Public Library; *Herald-Traveler* photograph by Ollie Noonan.)

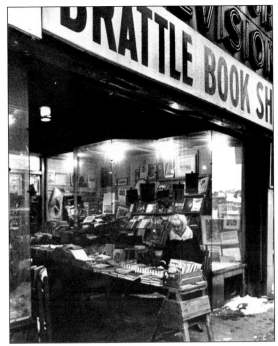

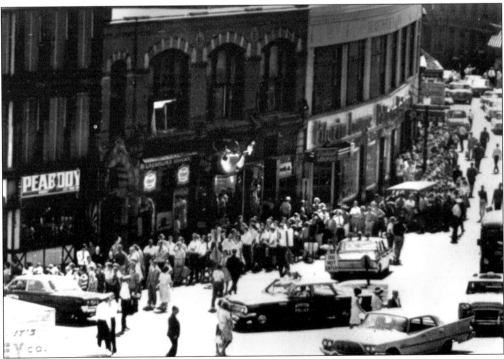

In May 1961, bookstore owner George Gloss made front-page news by inviting the public into his store with a most remarkable offer: all the books that customers could carry out would be theirs, for free! A crowd of 5,000 people lined up, and by closing time they had emptied the shop of 50,000 books, according to George's son Ken (who still operates the Brattle Book Store on West Street in Boston). (Courtesy Ken Gloss.)

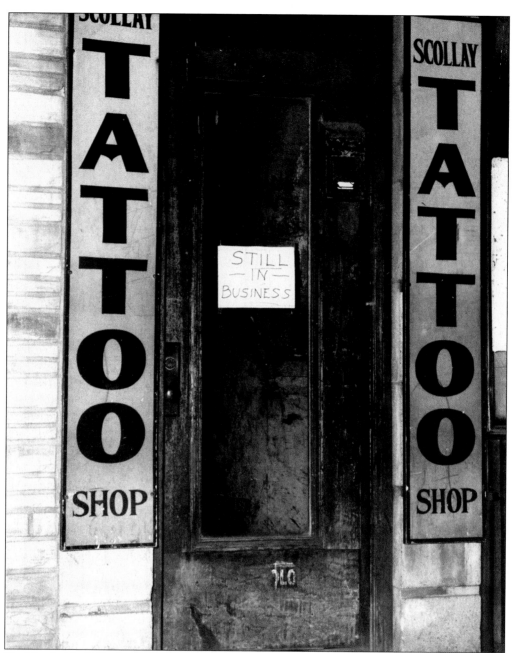

On March 18, 1962, the writing was on the wall (or, in this case, the arm, leg, or chest) for this tattoo parlor at 49 Scollay Square. Stephen Gilbert, author of *Tattoo History: A Source Book*, wrote: "Near the Casino was a tattoo shop owned by a man named Dad Liberty. He had one of those 'You must be 18' signs in his window, . . . but by then I was wise in the ways of the world, and one day I screwed up my courage and swaggered into Dad Liberty's shop and asked him to tattoo a little number 13 on my leg. He matter-of-factly told me to roll up my pants leg, and within a few minutes I had my first tattoo. I was hooked. The next week, after the burlesque show, I came back for crossed swords on the other leg. I have traveled far through time and space since then, but Dad Liberty's tattoos are still with me." (Courtesy Bostonian Society–Old State House.)

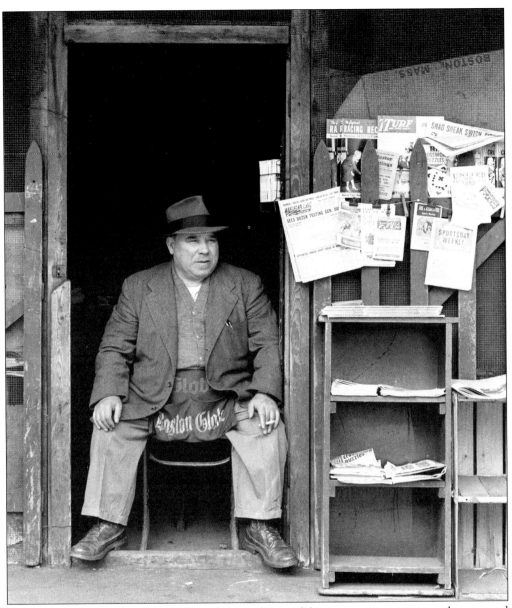

Hugh Mattison used to deliver the *Christian Science Monitor* to newspaper vendors around Boston. He told Brad Dalbeck of the Scollay Square Restaurant (at 21 Beacon Street): "There was an excitement to Scollay Square. . . . The Five Star and Final editions were literally warm off the press. Newspaper Row—home of the *Boston Post* and the *Boston Globe*—was a scant 200 yards away on Washington Street. Trucks would start to arrive, the drivers jumping up into the back to shove wire-wrapped bundles of newspapers with a thud and a slight bounce on the asphalt pavement, while dealers scrambled to pile them up around the MTA entrance. The newsdealer . . . was Jimmy, a fat, jovial fellow, who sat in a doorway next to the Rialto Theater. . . . The dealers were a hearty group, standing for long hours in all weather. I always marveled at how deftly they could count newspapers, using gloves with the fingers cut off, in the coldest weather. And of course their fingers were black from newsprint." (Courtesy Bostonian Society–Old State House.)

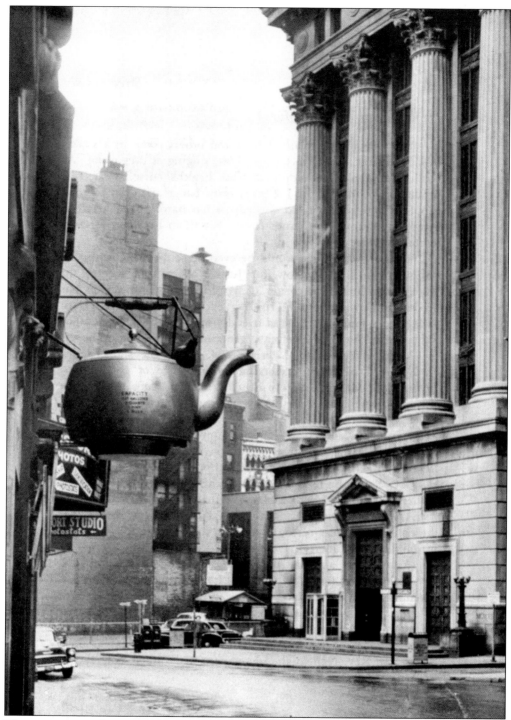

The ever-present Steaming Tea Kettle is shown in this 1950s-era photograph, taken from the opposite direction as the image on page 105. This view down Court Street points away from Scollay Square and toward the courthouse, which later became an annex for the old city hall on School Street, and then the school department's headquarters.

Seven

BUILDING
GOVERNMENT CENTER

This was the groundbreaking ceremony for the new Boston City Hall and City Hall Plaza. Mayor John Collins, seated behind the speaker's podium, had made urban renewal a cornerstone of his 1959 campaign and, once in office, he oversaw the plans for construction of a new Government Center.

Oops! This crane has fallen into the excavation it was digging for the new city hall's foundation in 1962. This eastward view looks toward Hanover Street, where all but one building—the one housing The Tasty and Ted's Tattoo Parlor—have been torn down. This allows clear sight of the buildings on Sudbury Street that would later be replaced by a massive parking garage.

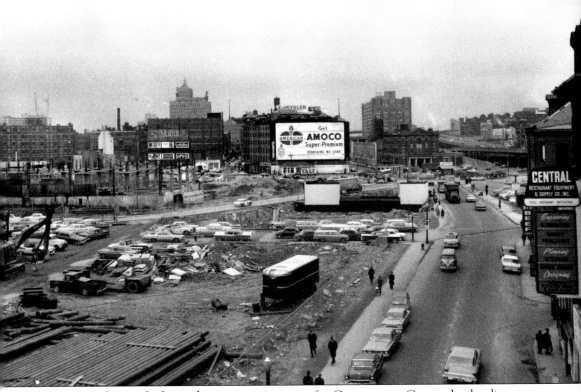

This view to the north shows the construction zone for Government Center. In the distance rise the towers of Charles River Park, an urban-renewal project that decimated the West End neighborhood, and displaced thousands of longtime residents. The Hotel Madison, where the Beatles stayed when they played the old Boston Garden in 1964, appears in the middle background. The "Tip" O'Neil Federal Building occupies that site today.

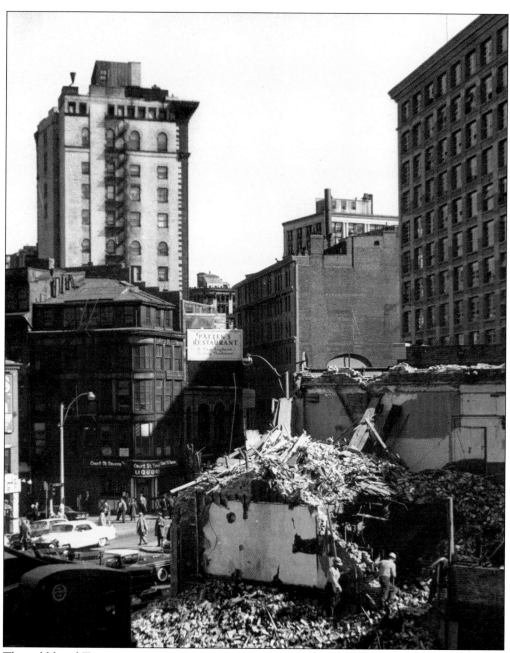

The rubble of Tremont Row, here in the foreground, makes Boston in 1961 look more like Berlin in 1945, although through the pile of bricks we see the head of Cornhill in Scollay Square, where life appears to be going on as usual. Patten's Restaurant was Boston's biggest, with more than 1,000 seats up on the second floor of the Sears Crescent Building. Owner William Dough was one of hundreds of business owners who received a check when his property was taken by eminent domain. According to his son Robert, William, not satisfied with the amount the city offered, went to court and won a larger judgment. In the background, rising behind the curve of the Crescent Building, is the Ames Building (see page 25), another remnant of old Scollay Square that remains today.

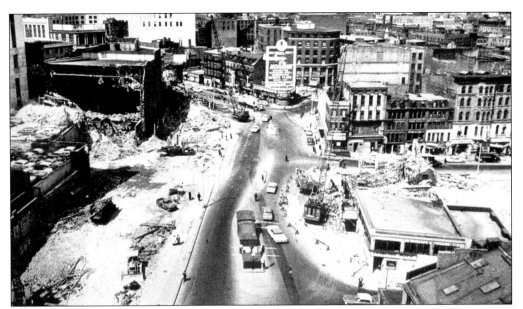

Tremont Row is torn down in 1962. Across the street, the Crawford House—the building a mere shell of its former self—hangs on for dear life. Within a few months, it, too, would fall to the wrecking ball. Ed Logue, the city planner for Mayor John Collins, served as a bombardier in Europe during World War II, an experience that he claimed helped in his job of redeveloping Boston.

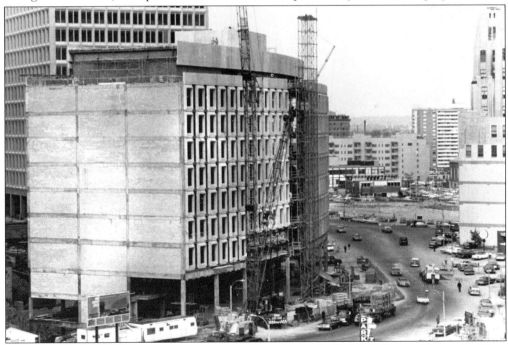

The replacement for Tremont Row would be Norm Leventhal's 1-2-3 Center Plaza, a building that Walter Muir Whitehill once described as "a 77-story-tall skyscraper mercifully laid on its side." In this 1965 photograph, the first portion, One Center Plaza, is nearing completion. In the distance, behind the New England Telephone Building in Bowdoin Square, is an apartment building of Charles River Park, which replaced the West End.

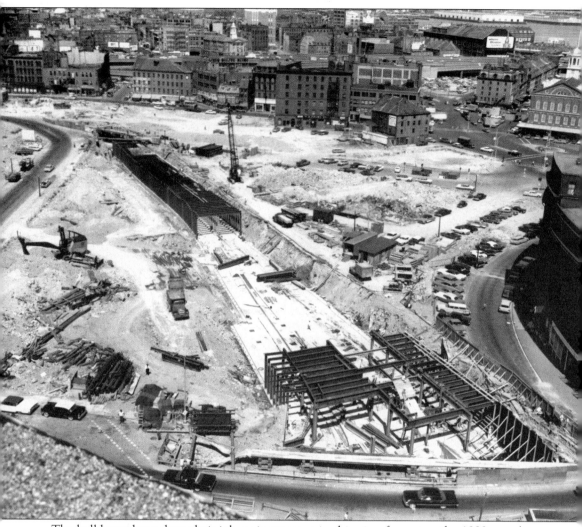

The bulldozers have done their job, as is apparent in this view from atop the 1939 courthouse, looking into the area that was Scollay Square, on July 7, 1963. The Sears Crescent Building remains at the far right, but Cornhill, Brattle, and Hanover Streets are all gone. Running diagonally across the photograph is the construction of the new subway.

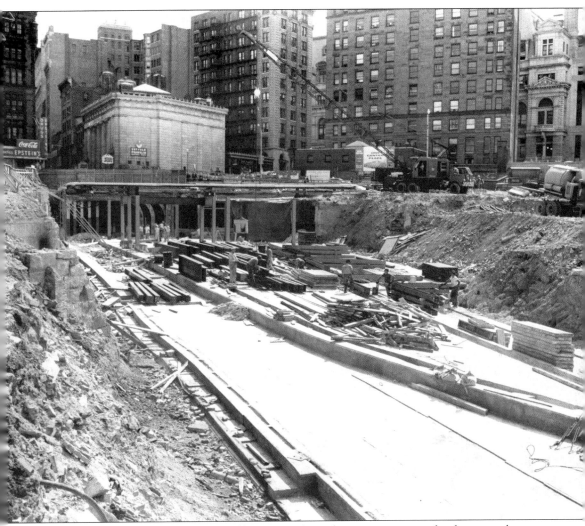

Pictured here is the view back into Scollay Square from the excavation site for the new subway tunnel, on July 5, 1963. Tremont Row is gone, and one can see directly into Pemberton Square. The construction of both One and Two Center Plaza would require the demolition of Barrister's Hall and several other buildings in Pemberton Square. The clock is ticking for the Suffolk County Savings Bank, too, which would be demolished to make way for Three Center Plaza.

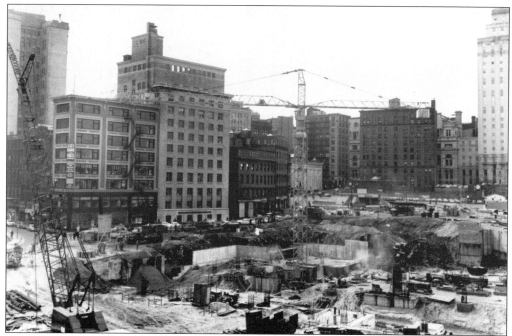

Taken about a year after the previous photograph, this is a view from Dock Square toward the bank. Foundation work is well under way for city hall. A section of the original Scollay–Adams Square subway tunnel remained untouched below city hall, and in the 1980s, it was found and converted into badly needed storage space. The new Government Center subway entrance, across from the bank, is open for passengers.

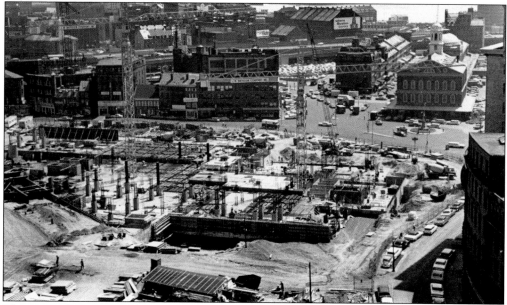

The new subway tunnel has been completed, as has the foundation for the new Boston City Hall. Because two large cranes of the J. W. Bateson Company needed to be anchored deeply in the ground to support the lifting of heavy stone and steel, the foundations were left there when the job was done, and became a part of city hall.

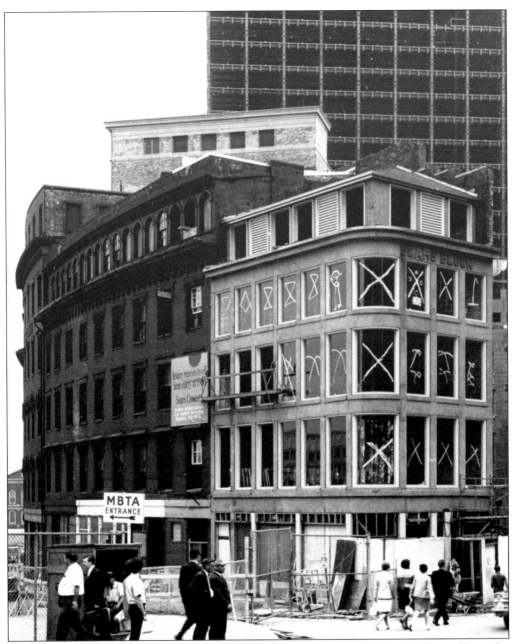

The era of historical preservation was years away, so despite some people's best efforts, the building on Cornhill where abolitionist William Lloyd Garrison published the *Liberator* was torn down. The Sears Crescent Building, however, was preserved by the Development Corporation of America, which was in the process of restoring the building when this photograph was taken in 1967.

In the early 1930s, because she was unable to make it on the so-called legitimate stage, Louise Hovick changed her name to Gypsy Rose Lee, and began performing striptease with a twist: she would often recite poems and other "intellectual" material while removing her clothes. Gypsy brought this act, which H. L. Mencken described with the word "ecdysiast," to Scollay Square's Old Howard on many occasions. Gypsy, whose life story was the subject of the Natalie Wood movie, would host her own talk show in the 1960s. The show aired locally on Channel 7, the studios for which were just across the street from the John F. Kennedy Federal Building. In this 1966 photograph, the former burlesque star takes advantage of an irresistible opportunity to pose in front of one of the buildings that had replaced Scollay Square. (Courtesy Boston Public Library.)

One of our last photographs during the construction of Government Center, fittingly, is that of the Steaming Tea Kettle, now restored at the head of the refurbished Sears Crescent Building. That the current tenants under the kettle are mainly purveyors of coffee has not stopped the kettle from continuing its 125-year mission.

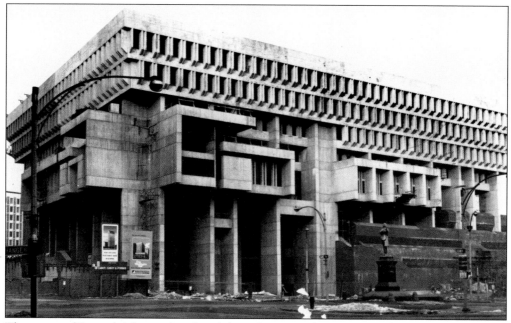

The statue of Samuel Adams, placed in Adams Square at the same time the statue of Governor Winthrop was placed in Scollay Square, seems to stare stoically at the new Boston City Hall in 1968. The result of a nationwide design competition, city hall is one of those buildings about which no one is neutral. Architectural critic Edward Durrell Stone once complained that it looked like the crate in which Faneuil Hall came.

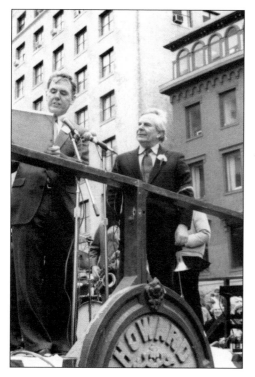

Save for the rare sports championship celebration, City Hall Plaza is a wind-swept, lonely desert of red brick. In 1986, radio host Jerry Williams, broadcasting from the plaza after a Celtics victory party, began a campaign to bring back the name Scollay Square to Government Center. On April 29, 1987, with Jerry watching, Mayor Raymond Flynn read the proclamation that officially restored Scollay Square to the street and subway signs.